Hawthorne's Haunts

IN NEW ENGLAND

Hawthorne's Haunts

IN NEW ENGLAND

JOHN HARDY WRIGHT

THE
History
PRESS

Published by The History Press
Charleston, SC 29403
www.historypress.net

Cover design by Natasha Momberger.

First published 2008
Second printing 2012

Manufactured in the United States

ISBN 978.1.59629.425.7

Library of Congress Cataloging-in-Publication Data

Wright, John Hardy.
Hawthorne's haunts in New England / John Hardy Wright.
p. cm.
Includes bibliographical references.
ISBN 978-1-59629-425-7
1. Hawthorne, Nathaniel, 1804-1864--Homes and haunts--Massachusetts--Pictorial works. 2. Authors, American--Homes and haunts--Massachusetts--Pictorial works. 3. Literary landmarks--Massachusetts--Pictorial works. I. Title.
PS1884.W75 2008
813'.3--dc22
[B]
2008017746

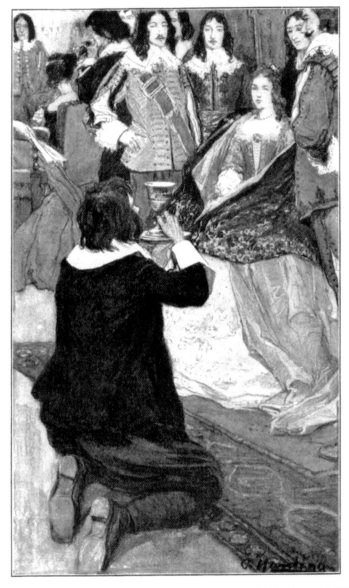

Illustration by Charlotte Harding in *The Works of Nathaniel Hawthorne* vol. III,
edited by Julian Hawthorne, 1900

"'Why do you haunt me thus?' said she [Lady Eleanore] *in a languid tone."*

Howe's Masquerade (pen-and-ink drawing by Frank T. Merrill, *In Colonial Days*, by Nathaniel Hawthorne, 1906)

Contents

Acknowledgements

Special individuals: Michael Blatty, Gary Borkan, Ames Fuller, Wendy M. Horne, Linda M. Kidder, Patricia R. Marcus, William K. Millar Jr., Everett Philbrook, Patricia A. Seagreaves, Jeanne Stella and *especially* Robert T. Derry, John V. Goff, Stephen J. Schier and Bonnie Hurd Smith.

Special individuals associated with institutions: Tom Beardsley, historic site manager, and Faith Ferguson, The Old Manse, the Trustees of Reservations, Concord, Massachusetts; Richard Lindemann, director, and Daniel Hope, archival assistant, George J. Mitchell Department of Special Collections and Archives, Bowdoin College, Brunswick, Maine; Christine Michelini, photo resources and archives manager, Peabody Essex Museum, Salem, Massachusetts; Emily A. Murphy, park ranger, Salem Maritime National Historic Site; Karen B. Pelletier, director of education and community services, The House of the Seven Gables; Teresa Wallace, PhD, curator, Minute Man National Historical Park, Concord, Massachusetts; Leslie Perrin Wilson, curator, William Munroe Special Collections, Concord Free Public Library; and *especially* Lorraine A. Allison, professor of American literature, Salem State College.

Introduction

Once, amid the troubled and tumultuous enjoyment of my life, there was one dreary thought that haunted me,—the terrible necessity imposed on mortals to grow old and die.
–Fragments from the Journal of a Solitary Man, 1837

The various "haunts" where Nathaniel Hawthorne (1804–1864) resided—alone, with his mother and two sisters or as a married man with a family—form the landscape of this pictorial history. In his *Note-Books* in 1840, a melancholy Hawthorne penned, "Here I sit in my old accustomed chamber [the Manning mansion on Herbert Street in Salem] where I used to sit in days gone by…Here I have written many tales—many that have been burned to ashes, many that have doubtless deserved the same fate. This claims to be called a haunted chamber, for thousands upon thousands of visions have appeared to me in it; and some few of them have become visible to the world."

The Salem-born author incorporated intriguing themes in his first two Gothic romance novels. The central point of view of *The House of the Seven Gables* (1851) is based on the misdemeanor of his ancestor, Colonel John Hathorne, "the hanging judge" of the witchcraft delusion of 1692. His father, Major William Hathorne (the first Salem settler of the family), preceded him, and was known for harassing Quakers and for having one woman of the sect whipped through the streets of Salem, Boston and Dedham. In the introduction to *The Scarlet Letter* (1850), Hawthorne wrote, "The figure of that first ancestor, invested by family tradition with a dim and dusky grandeur, was present to my boyish imagination as far back as I can remember. It still haunts me, and induces a sort of home-feeling with the past, which I scarcely claim in reference to the present, phase of the town." In the same novel, Hawthorne elaborated upon the family curse: "I know not whether these ancestors of mine bethought themselves to repent, and ask pardon of Heaven for their cruelties; or whether they are now groaning under the heavy consequences of them in another state of being. At all events, I, the present writer, as their representative, hereby take shame upon myself for their sakes, and pray that any curse incurred by them—as I have heard…may be now and henceforth removed." Hawthorne was definitely haunted by his Calvinist heritage and he added the "w" to his surname around 1827 to disassociate himself from his tainted relatives.

The noun "haunt" appears in the English language as early as circa 1230, according to the online *Oxford English Dictionary*. For an 1860 example of the word "haunted," the

dictionary gives the following phrase from Hawthorne's novel of that year, *The Marble Faun*: "A homeless dog, that haunted thereabouts." Two variations of the word "haunts" ("haunted" and "haunting") appear in his four famous novels: the aforementioned *The Scarlet Letter* and *The House of the Seven Gables*, and in *The Blithedale Romance* (1852) and *The Marble Faun* (1860), as well as in his fascinating short stories or tales. Macabre words and phrases are scattered throughout his writings, and are included in the titles of six tales: *The Haunted Quack* (1831), *The Wives of the Dead* (1832/1852), *Roger Malvin's Burial* (1832/1846), *The Devil in Manuscript* (1835/1852), *The Haunted Mind* (1835/1842) and *Graves and Goblins* (1835). (The first and last of the six tales are attributed to Hawthorne in *The Centenary Edition of the Works of Nathaniel Hawthorne*, volume XI; two dates in parentheses indicate the first publication date and when the tale was included in a book.)

Some "haunting" sentences from Hawthorne's works include: "But, even now, she [Alice Pyncheon] was supposed to haunt the House of the Seven Gables, and, a great many times—especially when one of the Pyncheons was to die—she had been heard playing sadly and beautifully on the [black] harpsichord." (*The House of the Seven Gables*) "She had been left to seek associates and friends for herself, in the haunts of imagination, and to converse with them, sometimes in the language of dead poets, oftener in the poetry of her own mind." (*Sylph Etherege*, 1838/1852) "For Mary Goffe had been buried in an English churchyard, months before; and either it was her ghost that haunted the wild forest, or else a dreamlike spirit, typifying pure Religion" (*The Man of Adamant*, 1837/1852).

In *Graves and Goblins*, variations of "haunt" appear seven times, and lugubrious words such as "buried," "death," "ghosts," "graves," "sepulcher," "tombstone" and "vault" appear eighty-five times. Twenty-three related doleful words show up in *The Haunted Quack*; seventeen in *The Haunted Mind*; sixty-two in one of Hawthorne's shortest tales, *The Wedding Knell* (1836/1837); and seventy-four in *The White Old Maid* (1835/1842), including "winding sheet," which is presented nine times. In *Feathertop; a Moralized Legend* (1852/1854), a delightful short story especially enjoyable around Halloween, the author has expanded upon his macabre word choices to include "bones," "devil," "hobgoblin," "skeleton" and "witch" (the latter appearing twenty-seven times) for a total word count of ninety-nine!

A reader of Nathaniel Hawthorne's works, or of the introduction to this book, might think that he was a morose man. His wife, Sophia, knew differently. In an 1848 letter written to her mother she stated, "He often writes truth, with characters of fire, upon an infinite gloom,—softened so as not to terrify, by divine touches of beauty,—revealing pictures of nature, and also the tender spirit of a child." And Henry Bright, one of Hawthorne's best friends in London, where the author and his family visited while he was the American consul in Liverpool between 1853 and 1857, wrote to son Julian after his father's death that Hawthorne "was almost the *best* man I ever knew,—and quite the most interesting. Nothing annoys me more than the word 'morbid' as applied to him,—he was the *least* morbid of men with a singularly sweet temper, and a very far-reaching charity." Several decades younger than Hawthorne, Bright went on to write that his American friend was "happy in all his domestic relations, happy in his own wonderful imaginative faculty, and in the fame which he had achieved."

Hawthorne's softer side, and the joy he found in the goodness of life, is expressed in *The Hall of Fantasy* (1843/1846) when he wrote of a picture-perfect day: "The fragrance of

flowers and of new-mown hay; the genial warmth of sunshine, and the beauty of a sunset among clouds; the comfort and cheerful glow of the fireside; the deliciousness of fruits and of all good cheer; the magnificence of mountains, and seas, and cataracts, and the softer charm of rural scenery."

Author's notes: The historical images of bachelor photographer Frank Cousins (1851–1925), who operated a successful business called the Bee-Hive at 170–174 Essex Street in Salem during the turn of the twentieth century, include several exterior and interior views used in *Hawthorne's Haunts in New England.* The rooms in Salem were photographed around 1890, during the high Victorian period, and those at The Wayside in Concord around 1904, during the Edwardian period, for the celebration of Hawthorne's 100th birthday. Although decades had passed since members of the Hawthorne family lived in them, these rooms were, and still are, considered "literary shrines." The Peabody Essex Museum in Salem has in its collection a vast quantity of Cousins's photographs and original glass plate negatives. Identical images in this book are from the collection of Stephen J. Schier; additional images are also from the Schier collection, Michael Blatty, Lorraine Allison and several institutions. Images not credited in the courtesy line are in this author's collection.

This pictorial biography of Nathaniel Hawthorne's life and writings is accompanied by his pertinent quotations; those of his son Julian; his daughter Rose; her husband, George P. Lathrop; Henry James; and other late nineteenth-century friends of Hawthorne. With the exception of a few early twentieth-century publications and two more recent guidebooks, I have relied mainly on the aforementioned primary sources for this book. It is not an all-inclusive biography—available images suggested the narrative.

Youthful Haunts

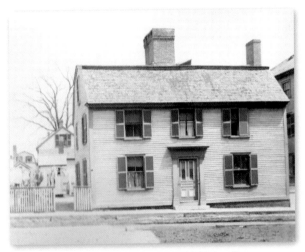

Birthplace of Nathaniel Hawthorne, 27 Union Street
(photograph by Frank Cousins, circa 1890)

"I was born in the town of Salem, Massachusetts, in a house built by my grandfather [Captain Daniel Hathorne], *who was a maritime personage. The old household estate was in another part of the town, and had descended in the family ever since the settlement of the country; but this old man of the sea exchanged it for a lot of land situated near the wharves, and convenient to his business, where he built the house…and laid out a garden, where I rolled on a grass-plot under an apple-tree and picked abundant currants."*
—Nathaniel Hawthorne, *National Review*, 1853

F ORMERLY LOCATED at 27 Union Street in the ancient, provincial town, this charming mid-eighteenth-century gambrel-roof dwelling faced the street when it was built and photographed, but it was oriented to face the harbor when it was moved in 1958 to the grounds of The House of the Seven Gables Settlement Association. Raised around 1750, it is thought that structural timbers from a seventeenth-century house on the site were incorporated in the framing of the small Georgian dwelling. In 1772, the house was acquired by Captain Daniel Hathorne, and following the tragic death of his son, Captain Nathaniel Hathorne, at sea in 1808, his widow took the children (Nathaniel and his two sisters) and moved back into her family home on Herbert Street.

THE EARLIEST IMAGE of a Hathorne family member is that of the author's paternal grandfather, Captain Daniel Hathorne (1731–1796), who was a privateer around the time of the Revolutionary War. "Bold Daniel's" wife, the former Rachel Phelps, was born in 1733/34 and died in 1813. They were interred in the town's earliest burying ground on Charter Street, as was the infamous witch trials judge, Colonel John Hathorne; however, the gravesite of the first ancestor of the Salem branch of the family, William Hathorne, is unknown.

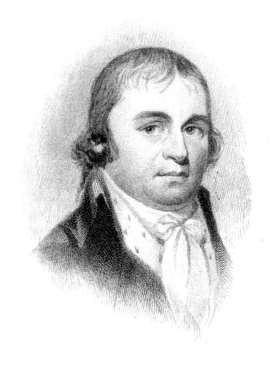

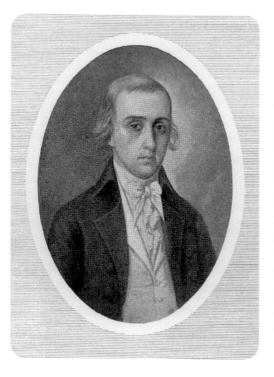

NATHANIEL WAS FOUR YEARS OLD when his father, Captain Nathaniel Hathorne (1775–1808), died of yellow fever in Surinam, in northern South America. The whereabouts of this miniature portrait in the neoclassical style (circa 1804) is unknown; it is now attributed to Spoilum, who worked in Canton, circa 1785–1810. Hathorne's widow, the former Elizabeth Clarke Manning (1780–1849), was supposedly a woman of noteworthy beauty whose unusual and lustrous light bluish-gray eyes were inherited by her son. She and her daughters, Elizabeth Manning Hathorne (1802–1883) and Maria Louisa Hathorne (1808–1852), became ostensibly reclusive for the remainder of their lives.

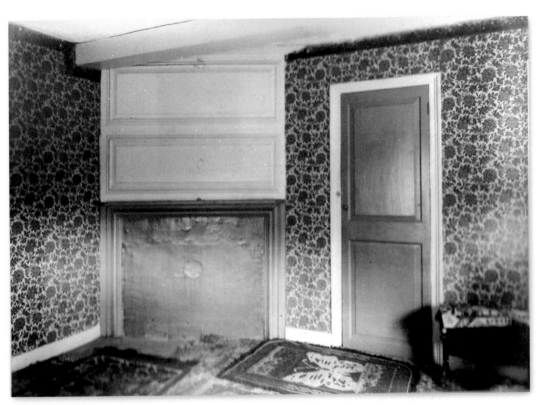

Parlor, birthplace (photograph by Cousins, circa 1890)

"Your father was born in 1804, on the 4ᵗʰ of July, in the chamber over the little parlor in the house in Union Street, which then belonged to my grandmother [Rachel Phelps] Hathorne, who lived in one part of it…I remember that one morning my mother called my brother into her room, next to the one where we slept, and told him that his father was dead. He left very little property, and my grandfather [Richard] Manning took us home."

–Letter written by Elizabeth Hathorne to her niece (either Una or Rose) a year or so after her father's death. Julian Hawthorne, *Nathaniel Hawthorne and His Wife*, 1897 (hereinafter referred to as JH, *Nathaniel Hawthorne and His Wife*)

THE TWO ROOMS on the left side of the house on the first and second floors have interesting corner fireplaces, this one next to the front door, with a bolection molding around the boarded-up opening, two raised panels above that and on the door and a supporting beam. An allover floral wallpaper and various rugs, one with a predominant butterfly, give the room a decidedly Victorian flavor, as do all the interior images taken by Frank Cousins. Hawthorne's daughter Rose wrote in *Memories of Hawthorne* (1897), "The Butterfly…floats everywhere through his pages, and it is broken wherever the heart of one of his characters breaks, for there sin has clutched its victim. It floats about us lovingly to attract our attention to higher things." (RHL, *Memories of Hawthorne*)

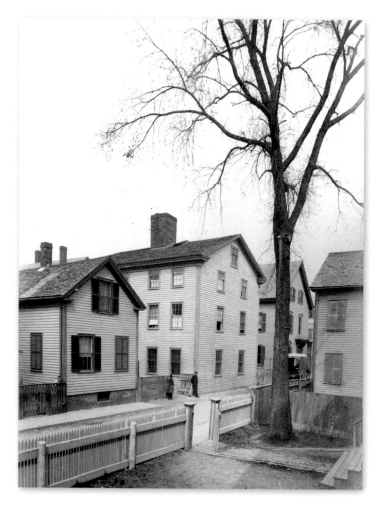

Richard Manning House, 10½–12 Herbert Street (photograph by Cousins, circa 1890)

"And thus it was that he entered upon that long vigil in the 'haunted chamber' of the family mansion in Herbert Street,—the antechamber of his fame."
–JH, *Nathaniel Hawthorne and His Wife*

HAWTHORNE'S BIRTHPLACE on Union Street was very near the 1793 three-story wood-framed dwelling known as the Manning Mansion, which he called "Castle Dismal." He had an apartment "under the eaves," and it was there, mainly in isolation, that Hawthorne wrote *Twice-Told Tales*, published in Boston in 1837 by the American Stationers Co. In the 1897 biography of his father and mother, Julian Hawthorne (1846–1934) quoted his father about this period: "Having spent so much of my boyhood and youth away from my native place, I had very few acquaintances in Salem, and during the nine or ten years that I spent there, in this solitary way, I doubt whether so much as twenty people in the town were aware of my existence." The aspiring author also wrote that "it seemed as if I were already in the grave, with only life enough to be chilled and benumbed."

Richard Manning House, Raymond, Maine (pen-and-ink drawing by an unidentified artist, nineteenth century)

"At Raymond, in Maine, my grandfather [Richard Manning] *owned a great deal of wild land. Part of the time we* [Nathaniel, his mother and two sisters] *were at a farmhouse belonging to the family, as boarders, for there was a tenant on the farm; at other times we stayed at our uncles'* [Robert Manning]. *It was close to the great Sebago Lake, now a well-known place."*
–JH, *Nathaniel Hawthorne and His Wife*

DURING THIS CAREFREE nine-month period, Nathaniel recalled, "I lived in Maine like a bird of the air, so perfect was the freedom I enjoyed. But it was there I first got my cursed habit of solitude." He also attended school in Portland, and on rainy days delved into the works of British authors William Shakespeare and John Bunyan.

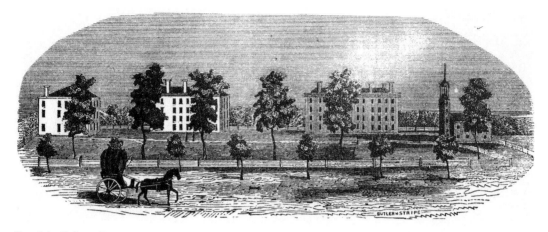

Bowdoin College, Brunswick, Maine (wood engraving by Butler and Stripe, circa 1849; courtesy George J. Mitchell Department of Special Collections and Archives, Bowdoin College)

"While we were lads together at a country college [Bowdoin],—*gathering blue-berries, in study-hours, under those tall academic pines; or watching the great logs, as they tumbled along the current of the Androscoggin; or shooting pigeons and gray squirrels in the woods; or bat fowling in the summer twilight; or catching trouts in that shadowy little stream—doing a hundred things that the Faculty never heard of."*
–preface to *The Snow-Image*, 1850/1852

JAMES BOWDOIN, a graduate of Harvard College, established this rural college by an endowment of money and land and it was chartered by the General Court of Massachusetts in 1794, because Maine did not become a state until 1820. Bowdoin College is approximately thirty miles from Raymond, and picturesque Casco Bay is nearby. The brick buildings depicted in the print are, *left to right*: Massachusetts Hall, Winthrop Hall and Maine Hall (where Nathaniel and his roommate, Alfred Mason, boarded); the typical, wood-framed meetinghouse-style chapel is on the right. Nathaniel Hawthorne entered Bowdoin College in 1821, his seventeenth year, and he graduated four years later on September 7, 1825, eighteenth in a class of thirty-nine. College chums and lifelong friends included Franklin Pierce and Horatio Bridge; another friend, Jonathan Cilley, was killed in a duel in 1838.

Andrew Dunning House, 76 Federal Street, Brunswick, Maine (postcard, circa 1905)

"I was educated (as the phrase is) at Bowdoin College. I was an idle student, negligent of college rules and the Procrustean details of academic life, rather choosing to nurse my own fancies than to dig into Greek roots and be numbered among the learned Thebans…On leaving college in 1825, instead of immediately studying a profession, I sat myself down to consider what pursuit in life I was best fit for."
–JH, *Nathaniel Hawthorne and His Wife*

GEORGE PARSONS LATHROP (1851–1898), Hawthorne's son-in-law and first biographer, wrote in 1887 that "Hawthorne boarded in a house which had a stairway on the outside," as also indicated by the inscription on this postcard; therefore he must have boarded here and at the college at different times. The hipped-roof Andrew Dunning House was built around 1807 and is not far from the stream that formerly flowed in the Federal and Green Street area where the "average student" enjoyed fishing alone or with a classmate.

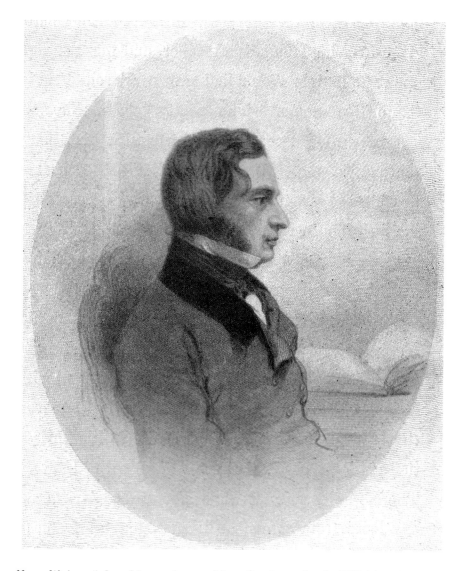

Henry Wadsworth Longfellow at the age of forty-four (engraving, by W.H. Mote, 1854)

"I remember, too, a lad just from college, Longfellow by name, who scattered some delicate verses to the winds."
–*P.'s Correspondence,* 1845/1846

BOTH ATTRACTIVE YOUNG MEN, Nathaniel was given the nickname "Oberon" for his good looks and for "the imaginative tone of his conversation." Shortly after *The House of the Seven Gables* was published in early 1851, Longfellow (1807–1882) sent a congratulatory note from Nahant, Massachusetts, to Hawthorne, who was then living in the Berkshires with his family. Longfellow wrote that he endorsed all that the critic in *Literary World* had to write about Nathaniel's book.

"What do you think of my becoming an author, and relying for support on my pen? Indeed, I think the illegibility of my handwriting is very author-like. How proud you would feel to see my works praised by the reviewers…But authors are always poor devils, and therefore Satan may take them."
—JH, *Nathaniel Hawthorne and His Wife*

Harriet Beecher Stowe House, 63 Federal Street, Brunswick, Maine (postcard, circa 1900)

IN A LETTER WRITTEN IN SALEM on March 13, 1821, Nathaniel posed the aforementioned question to his mother. Harriet Beecher Stowe (1811–1896), the author of *Uncle Tom's Cabin* (1852), resided in this white Greek Revival–style house with its original urn-topped fence and interesting trellis decoration for only three years. Her husband, Calvin E. Stowe, was a professor of biblical studies at Bowdoin College. Both families, with their children, became reacquainted on the transatlantic voyage from England to America in June of 1860.

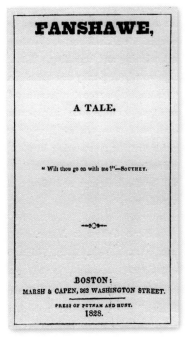

But if mortal man could recover the girl [Ellen Langton], *that fellow* [Fanshawe] *would do it—even if he had no better nag than a broomstick, like the witches of old times."*
—*Fanshawe*, 1828

THE FIRST MENTION of "witches" in a work by Hawthorne appears twice in *Fanshawe*. He published the tale anonymously three years after graduating from Bowdoin College, but because he felt the work was inadequate, the novice novelist destroyed as many copies as possible, making this tale exceedingly rare to find. Hawthorne was so ashamed of his first attempt at publication (which cost him approximately $100 in out-of-pocket expenses) that he swore his friends to secrecy about it, and his wife, Sophia, only heard of *Fanshawe* after his death. A similar fate occurred when he destroyed the manuscript of *Seven Tales of My Native Land*, a collection of short stories. Hawthorne was one of about a dozen American authors in the 1830s who were published.

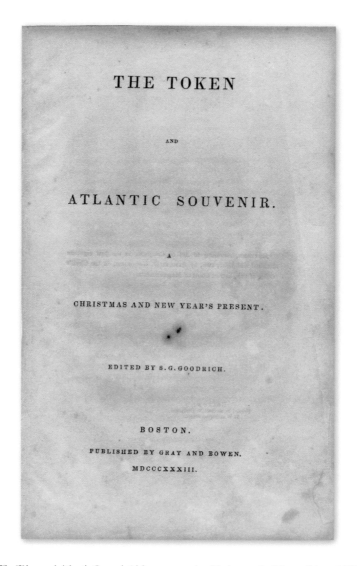

THE TOKEN

AND

ATLANTIC SOUVENIR.

A

CHRISTMAS AND NEW YEAR'S PRESENT.

EDITED BY S. G. GOODRICH.

BOSTON.

PUBLISHED BY GRAY AND BOWEN.

MDCCCXXXIII.

The Token and Atlantic Souvenir (title page to the Christmas holiday edition, 1833)

"In the Token *for 1832 are some of the first stories which I wrote...I have burnt whole quires of manuscript stories, in past times—which, if I had them now, should be at your service."*
–The Letters, 1813–1843

SAMUEL GRISWOLD GOODRICH published the popular annual *The Token* and, under the pseudonym Peter Parley, also produced many schoolbooks. Hawthorne contributed several short stories to the annual publication in the 1830s, such as *Sights from a Steeple*; *The Gentle Boy*; *The Wives of the Dead*; *My Kinsman, Major Molineux*; and *Roger Malvin's Burial*. In 1836 he became editor of the ill-fated *The American Magazine of Useful and Entertaining Knowledge*.

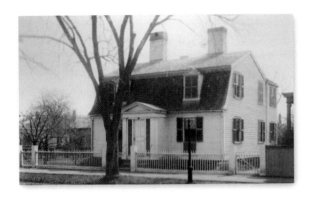

Robert Manning House, 26 (formerly 31) Dearborn Street, Salem (photograph by Cousins, circa 1890)

"Never did a pilgrim approach Niagara [Falls] with deeper enthusiasm, than mine."
—*My Visit to Niagara,* 1835

AMERICA'S LEADING POMOLOGIST, Robert Manning, had this small, Dutch gambrel-roof house built for his sister, Nathaniel's mother; Robert lived next door at number 33. The Hathorne family resided in North Salem for about four years (1828 to 1832), and then they returned to the Herbert Street homestead. During the 1830s, Nathaniel took stagecoach trips by himself to parts of Connecticut, New Hampshire, New York and Vermont, where he observed the sights and the daily life of his fellow man. Hawthorne wrote in *Passages from the American Note-Books* (1835–1853), "In Connecticut, and also sometime in Berkshire, the villages are situated on the most elevated ground that can be found, so that they are visible for miles around."

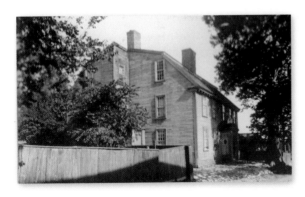

Derby-Ward House, 27 Derby Street, Salem (photograph by Cousins, circa 1890)

"In an old house, a mysterious knocking might be heard on the wall, where had formerly been a doorway, now bricked up."
—*Passages from the American Note-Books,* 1835–1853

THIS AMPLE COLONIAL DWELLING was built circa 1738 for Richard Derby and it was here that his sons Elias Hasket (a prosperous merchant), Richard (a statesman) and John (a ship's captain) were born. A century later, the house was owned by Nathaniel Hawthorne's relatives, the Jacob Crowninshield family, who offered a chamber to the young man where he could sleep, eat with them and enjoy the garden with its summer house.

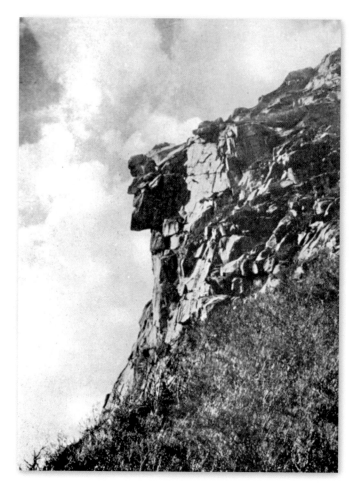

The Old Man of the Mountain, Franconia Notch, New Hampshire (photograph, 1882)

"The mists had congregated about the distant mountain-side, and there were seen the grand and awful features of the Great Stone Face, awful but benignant, as if a mighty angel were sitting among the hills, and enrobing himself in a cloud-vesture of gold and purple."
—The Great Stone Face, 1850/1852

A MUST-SEE TOURIST ATTRACTION until quite recently, when the stone face collapsed, the "Old Man of the Mountain" made an impression on Hawthorne, who composed four tales revolving around the famous stone icon. *The Great Stone Face and Other Tales of the White Mountains* was published with five illustrations by Houghton, Mifflin & Company initially in 1882. In the earliest of the four collected short stories, *The Ambitious Guest* (1835/1842), the author describes the fate of the Willey family who were crushed to death by a tremendous rockslide. *Sketches from Memory* (1835/1854) presaged *The Great Carbuncle* (1837), and *The Great Stone Face* revolves around the main character, Ernest, whose features eventually resemble those of the "profile mountain."

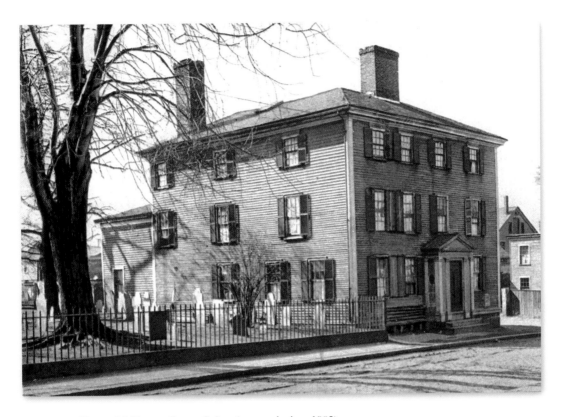

Grimshawe House, 53 Charter Street, Salem (postcard, circa 1905)

"The Doctor [not Dr. Grimshawe] *visited all the sick chambers for miles about…and sometimes raised a dying man, as it were, by miracle, or, quite as often, no doubt, sent his patient to a grave that was dug many a year to soon."*
–Ethan Brand, 1850/1852

DR. NATHANIEL PEABODY, a dentist, and his wife, Elizabeth Palmer Peabody, the parents of three sons and three daughters, called this circa 1770 foursquare dwelling their home between 1835 and 1840, before the family moved to Boston. Abutting "the Burying Point" cemetery (where Hawthorne's ancestors were interred), it was here that Elizabeth, one of the Peabody daughters, invited the author of *Twice-told Tales* (1837) and his sisters to call at the house. On November 11, 1837, the youngest daughter, Sophia, caught the budding author's eye; after a soured relationship with the much sought-after socialite, Mary Silsbee of Salem, ended, Hawthorne courted Sophia, who he began to call his "Dearest Dove."

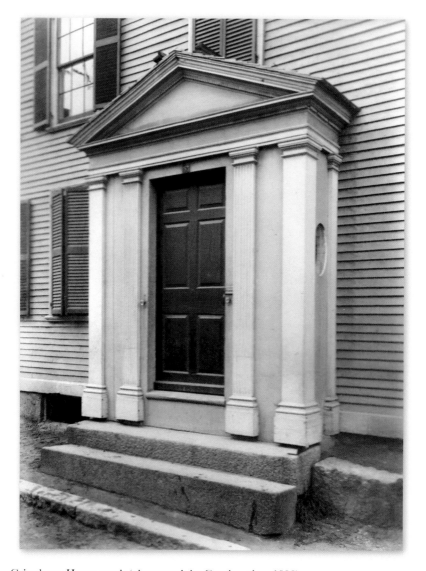

Grimshawe House porch (photograph by Cousins, circa 1890)

"A three-story wooden house, perhaps a century old, low-studded, with a square front, standing right upon the street, and a small enclosed porch, containing the main entrance, affording a glimpse up and down the street through an oval window on each side."
–JH, *Nathaniel Hawthorne and His Wife*

THE REAR DOOR of the "obviously degenerated" house, as Theodore F. Wolfe described the property in *Literary Shrines* (1895), was very close to the burying ground. Hawthorne fantasized that the dead might creep out of their graves at night and enter the house for warmth by the fireside.

The Gentle Boy (line drawing by Sophia A. Peabody, which appeared as the frontispiece to Hawthorne's rare edition of the same name, 1839)

"One day she showed him her illustration of The Gentle Boy, *saying 'I want to know if this looks like your Ilbrahim?' He sat down and looked at it, and then looked up and said, 'He will never look otherwise to me.'"*
—JH, *Nathaniel Hawthorne and His Wife*

CREATIVE VISUALLY AND EXPRESSIVE in her letters, Sophia accompanied her sister Mary to Cuba in 1833, hoping to relieve her migraine headaches while Mary worked as a governess at a plantation. The more than seven hundred letters Sophia wrote home describing the flora and fauna of Cuba were bound into three volumes to document the trip. Boston artist Washington Allston (1779–1843) encouraged Sophia to continue making copies in oils of European landscapes, which she may have seen at the Boston Athenaeum. Regarded as a "copyist" in her paintings, Sophia was talented with pen on paper; her line drawings, such as this most famous one, were influenced by those of the British neoclassical artist John Flaxman II (1755–1826). She also modeled a bust of twelve-year-old blind girl Laura Bridgman, who wore a covering over her eyes.

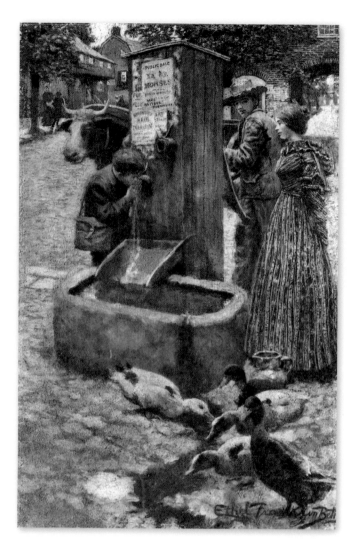

A Rill from the Town-Pump, in *Twice-Told Tales*, 1837 (oil painting, by Ethel Franklin Betts for the frontispiece of *The Complete Works of Nathaniel Hawthorne*, Fireside Edition, 1889)

"Pure as the current of your young life."
–A Rill from the Town-Pump

THE LOQUACIOUS, LIFE-SUSTAINING town pump that happens to be the narrator of this whimsical short story states how "I perform some of the duties of the town clerk, by promulgating public notices, when they are posted on my front." The town pump that Hawthorne knew so well was located at the intersection of Essex and Washington Streets, in the center of the city. A sculptural fountain was designed in the 1970s to commemorate the town pump, along with the construction of the Essex Street pedestrian mall, under the auspices of the Salem Redevelopment Authority.

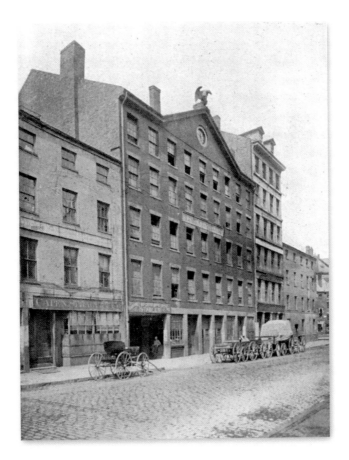

Old Custom House, Custom House Street, Boston waterfront (photograph, taken before the fire of 1894)

"I pray that in one year more I may find some way of escaping from this unblest Custom House; for it is a very grievous thralldom."
—Passages from the American Note-Books, 1835–1853

ON JANUARY 17, 1839, during the administration of Martin Van Buren, the eighth president of the United States, Hawthorne was appointed measurer at the Boston Custom House. The small post was suggested by the historian and collector of the Custom House, George Bancroft, and it came with an annual salary of $1,500. His first civil service job kept Hawthorne employed for about two years, until the Whigs came into office, when he resigned from that position of his own volition. On July 15, 1839, while boarding in Boston, he wrote to Sophia, to whom he was conditionally engaged and later married: "I am so busy at the Custom House these two or three days. I put [your letter] in my pocket, and did not read it till just now, when I could be quiet in my own chamber; for I always feel as if your letters were too sacred to be read in the midst of people, and (you will smile) I never read them without first washing my hands."–JH, *Nathaniel Hawthorne and His Wife*

Brook Farm and The Old Manse

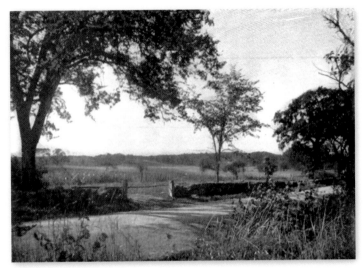

Site of Brook Farm, 679 Baker Street, West Roxbury, Massachusetts (photograph, 1898)

HAWTHORNE ARRIVED at the new utopian community in April of 1841 and left after seven months, although the group flourished for about four years. Around the first of May he wrote to his sister Louisa, "At the first glimpse of fair weather, Mr. [George] Ripley summoned us into the cow-yard, and introduced me to an instrument with four prongs, commonly entitled a dung-fork. With this tool I have already assisted to load twenty or thirty carts of manure, and shall take part in loading nearly three hundred more…This very morning I milked three cows and I milk two or three every night and morning." In addition to Dr. Ripley, Charles A. Dana and Minot Pratt were also leaders of the Transcendental community; Mrs. Ripley and Margaret Fuller (later an editor and a prominent feminist author) were soul mates in the kitchen. Hawthorne was not a Transcendentalist, an abolitionist or a Fourerite, as were his communal companions to one degree or another. (*The Letters, 1813–1843*)

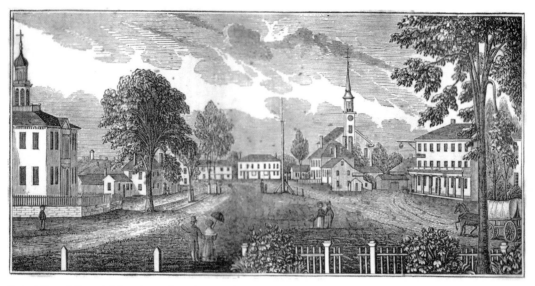

Central Part of Concord, Massachusetts (wood engraving in John Warner Barber's *Historical Collections of Every Town in Massachusetts*, 1841)

"*Every day I trudge through snow and slush to the village, look into the post-office, and spend an hour at the reading-room; and then return home, generally without having spoken a word to any human being…In the way of exercise I saw and split wood, and physically I was never in a better condition than now.*"

–Henry James Jr., *Nathaniel Hawthorne*, 1879

SITUATED IN MIDDLESEX COUNTY, the historic town of Concord was made famous on April 19, 1775, like neighboring Lexington, by the opening bloody events of the Revolutionary War. When Nathaniel Hawthorne moved there with his bride in July of 1842, the town was a peaceful retreat from his Brook Farm experience. Depicted in this wood engraving is part of the hipped-roof courthouse with its tall steeple; the Middlesex Hotel is on the opposite side of Main Street, as is the Unitarian Church. All of these structures, and practically every other wood-frame building represented, have been replaced or remodeled. Regarding some of the local inhabitants, perhaps before he knew them better, Hawthorne noted, "Never was a poor little country village infested with such a variety of queer, strangely-dressed, oddly-behaved mortals, most of whom look upon themselves to be important agents of the world's destiny, yet were simply bores of a very intense water" (an antiquated word referring to a peculiar temperament). (*The Letters, 1813–1843*)

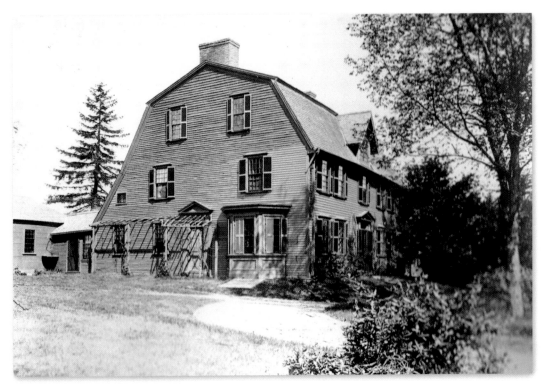

The Old Manse, 269 Monument Street, Concord (photograph by Cousins, circa 1890)

"Between two tall gateposts of rough hewn stone…we beheld the gray front of the old parsonage, terminating the vista of an avenue of black ash trees…The glimmering shadows that lay half asleep between the door of the house and the public highway were a kind of spiritual medium, seen through which the edifice had not quite the aspect of belonging to the material world."
–Mosses from an Old Manse (1846/1854)

THE HOME TO GENERATIONS of ministers and built in 1770 for one, the Patriot-minister Reverend William Emerson, The Old Manse was the abode of his grandson Ralph Waldo Emerson, who began writing "Nature," his first published essay, there. Newlyweds Nathaniel and Sophia, who were married in her parents' Boston home on July 9, 1842, rented the picturesque house for the "three happiest years" of their lives; they envisioned themselves as a "modern Adam and Eve." Nathaniel wrote that the garden "that skirted the avenue of the Manse, was of precisely the right extent. An hour or two of morning labor was all that it required. But I used to visit and revisit it a dozen times a day, and stand in deep contemplation over my vegetable progeny with a love that nobody could share or conceive of who had never taken part in the process of creation."

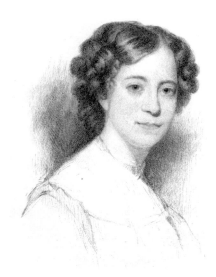

Sophia Amelia Peabody (engraving by Stephen Alonzo Schoff, 1884, after the oil portrait by Chester Harding, circa 1845)

ALTHOUGH "her physical world [was] a torture and a weariness, it illuminated and beautified the world of her spirit. It taught her endurance, charity, self-restraint, and brought her acquainted with the extent and wealth of her internal resources…Her face was so alive and translucent with lovely expressions that it was hard to determine whether or not it were physically lovely…[however] I have never seen a woman whose countenance better rewarded contemplation."–JH, *Nathaniel Hawthorne and His Wife*

"Your letters delight me more than anything, save the sound of your voice; and I love dearly to write to you…You are beautiful, my own heart's Dove. Never doubt it again."

Salem valentine (watercolor and pencil on paper, circa 1835; author's collection)

NATHANIEL WROTE those sentimental thoughts in a letter to Sophia on April 19, 1839. The valentine, with its pair of doves holding a banner with similar words, is typical of the period and has a die-cut gilded border.

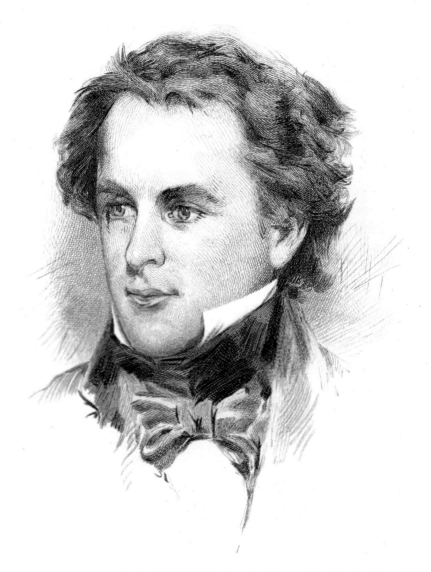

Nathaniel Hawthorne (engraving by Schoff, 1884, after the oil portrait by Charles Osgood, 1840)

"There is a difficulty in reconciling the outward calm and uneventfulness of his young manhood with the presence of those qualities which are known to have been in him…a young man, brimming over with physical health and strength; endowed…with a strong social instinct; with a mind daring, penetrating, and independent; possessing a face and figure of striking beauty and manly grace; gifted with a stubborn will, and prone, upon occasion, to outbursts of appalling wrath…but he was many-sided, unimpulsive, clear-headed; he had the deliberation and leisureliness of a well-balanced intellect."
–JH, *Nathaniel Hawthorne and His Wife*

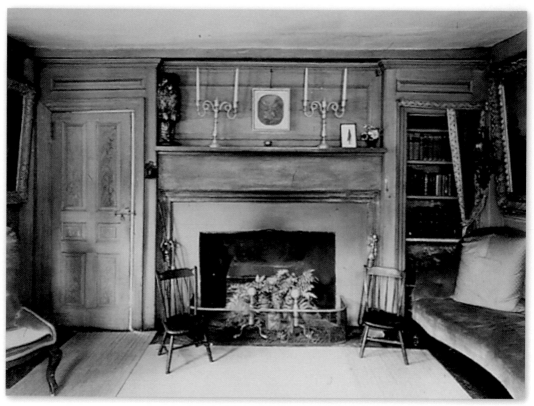

Small parlor, The Old Manse (circa 1890 photograph; courtesy of the Trustees of Reservations)

"After removing the ghosts and cobwebs from the drawing-room, Hawthorne asserted that 'the shade of our departed host [Dr. Ripley] will never haunt it; for its aspect has been so completely changed as the scenery of a theatre. Probably the ghost gave one peep into it, uttered a groan, and vanished forever.'"

—James, *Nathaniel Hawthorne*

THE INTERIOR ARCHITECTURE of The Old Manse dates to its construction in 1770, with raised paneling and window shutters painted in rich shades, while the furnishings date from the Colonial to the mid-Victorian period. Keeping watch on the mantelpiece by day and night is "Longfellow," the stuffed great horned owl so nicknamed by the Hawthorne family. The curvaceous silver candelabra belonged to the Bliss/Emerson family.

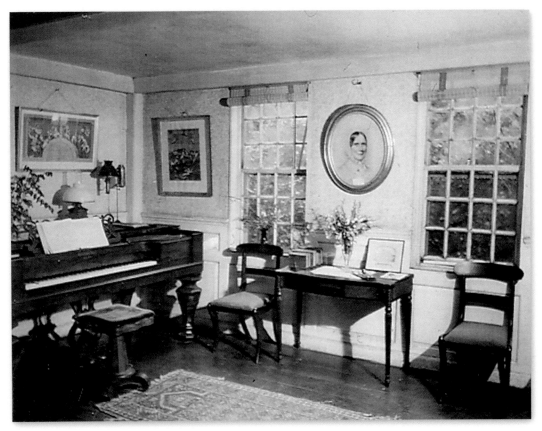

Large parlor, The Old Manse (photograph, circa 1899; courtesy of the Trustees of Reservations)

"On my father's side of the family there had been a distinct trait of material elegance, appearing in such evidences as an exquisite [porcelain] tea-service, brought from China by my grandfather, with the intricate monogram and dainty shapes and decoration of a hundred years ago; and in a few chairs and tables that could not be surpassed for graceful design and finish."
–RHL, *Memories of Hawthorne*

THE MID-NINETEENTH-CENTURY pencil portrait of Lucia H. Simmons, a member of the Emerson and Ripley families, was on display when the sepia-toned photograph was taken; it is shown above a Federal-period mahogany card table, flanked by a pair of Empire side chairs made of the same solid-grained wood preferred by cabinetmakers working in the neoclassical style. The Steinway grand piano was made in New York City in 1864, coincidentally the year of Nathaniel Hawthorne's death.

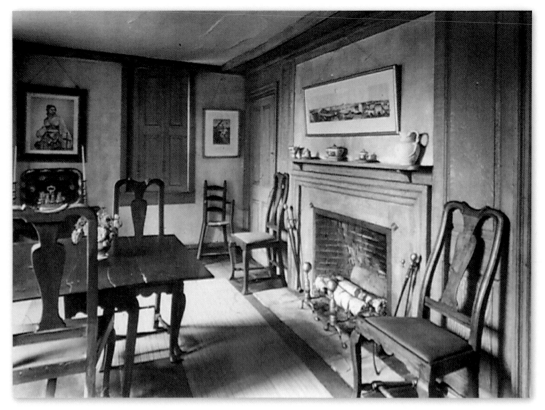

Dining room, The Old Manse (photograph, circa 1880; courtesy of the Trustees of Reservations)

*"Una Hawthorne stood on this window sill January 22d 1845 while the trees were all glass
chandeliers —a goodly show which she liked much tho' only ten months old."*
–JH, *Nathaniel Hawthorne and His Wife*

THE SHUTTERED WINDOW has glass panes with one inscription by a Ripley family member
and two by the Hawthornes. Sophia scratched the above maternal message, obviously
hoping it would remain forever—which it has! Una, the first of the Hawthornes' three
children, was born on March 3, 1844. A panoramic print of Leipzig, Germany, hangs over
the shallow mantelpiece with its assorted ceramic pieces. Sophia's "pleasant little breakfast
room" overlooks the river and marsh and is shown here with a Queen Anne table and
leather-covered side chairs of the same period.

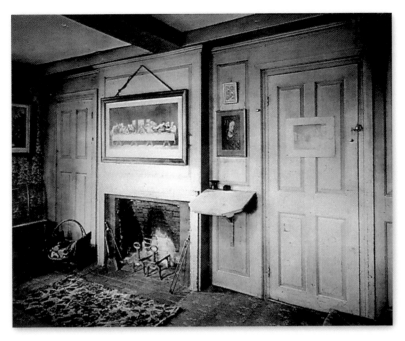

Study, The Old Manse (photograph, circa 1899; courtesy of the Trustees of Reservations)

"And this little study, where now an unworthy successor, not in the pastoral office, but merely in his earthly abode, sits scribbling beside an airtight stove."
—Fire-Worship, 1843/1846

HAWTHORNE WROTE on the small, ratchet-type desk attached to the wall opposite the windows, so that he would not be tempted by the view when writing a tale. Sophia wrote about "the dear hanging astral, that lighted my husband in his study." The prolific author penned twenty sketches and stories at The Old Manse, including *The Birth-mark, The Artist of the Beautiful, Rappaccini's Daughter, Egotism; or, The Bosom-Serpent, Drowne's Wooden Image, The Celestial Rail-road* and *Earth's Holocaust*. Sophia diamond-etched a windowpane here in the study with a memorable remark, as did Nathaniel:

Man's accidents are God's purposes
Sophia A. Hawthorne 1843

Nath' Hawthorne This is his study 1843
The smallest twig leans clear against the sky.
Composed by my wife, and written with her diamond
Inscribed by my husband at sunset April 3d 1843
On the gold light—SAH

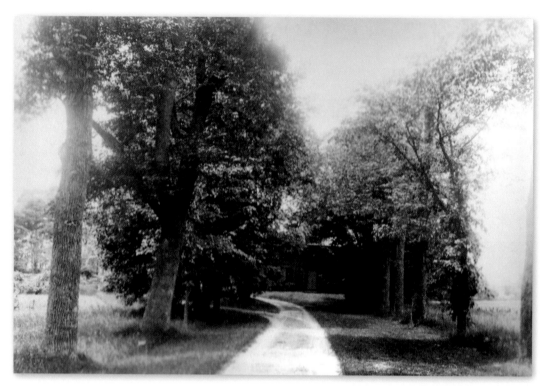

Pathway to The Old Manse (photograph by Cousins, circa 1890)

"[We] *gathered up our household goods, drank a farewell cup of tea...and passed forth between the tall stone gateposts as uncertain as the wandering Arabs where our tent might next be pitched.*"
−*The Old Manse,* 1846

ALONG THE CONCORD RIVER'S SHORE, Hawthorne kept a boat, built by and acquired from his friend Henry David Thoreau. He rechristened the vessel the *Pond Lily*, and in it he would return with many delicately colored blooms to decorate the abode he and Sophia loved so much. Money problems had plagued the family by their second year at the Manse, and Nathaniel had high hopes that influential friends might help him secure the position of postmaster or surveyor in Salem.

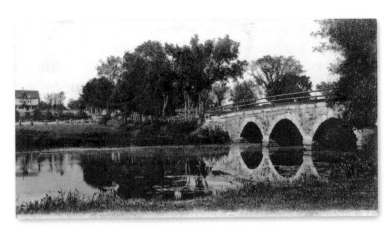

"[We] have voyaged on the [Concord] river constantly [Sophia wrote], harvesting water-lilies; and lately cardinal-flowers, which enrich the borders with their superb scarlet mantles in great conclaves." —RHL, *Memories of Hawthorne*

Stone Bridge, Elm Street, Concord (postcard, circa 1905)

AT THIS, or perhaps another local bridge, Hawthorne and his boating companion, Ellery Channing (1818–1901), assisted in recovering the water-logged body of a young woman who had committed suicide; the unexpected event made a lasting impression on both men. Hawthorne used it to advantage for Zenobia's tragic demise in *The Blithedale Romance* of 1852. While residing at The Old Manse, he penned two darkly scientific tales that deal with anxiety and sexuality, *The Birth-mark* (1843/1846) and *Rappaccini's Daughter* (1844/1846).

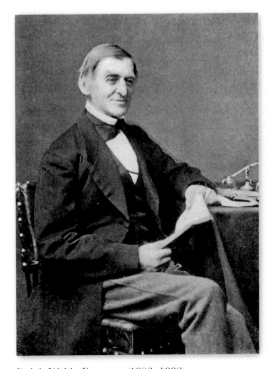

"WE WERE INTERRUPTED by no one [during the Hawthornes' first winter at the Manse except]...Mr. Emerson, whose face pictured the promised land...and intruded no more than a sunset, or a rich warble from a bird," wrote Sophia to a female friend in Salem in December 1842, about Concord's most famous resident.–RHL, *Memories of Hawthorne*

Ralph Waldo Emerson (1803–1882)

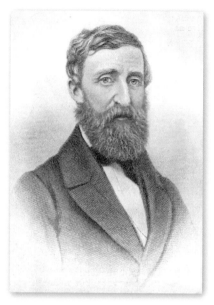

"Mr. Thoreau…is a singular character…with much of wild, original nature still remaining in him; and so far as he is sophisticated, it is in a way and method of his own."
–JH, *Nathaniel Hawthorne and His Wife*

THOREAU AND EMERSON, both Transcendentalist essayists and poets, were original thinkers in their day.

Henry David Thoreau (1817–1862)

"Mr. Alcott's sublime simplicity and depth of soul would make it impossible for me to make jest of him…I do not believe he is in the least self-elated. I should think it impossible, in the nature of things, for him to arrive at the kind of truths he does without entire simplicity of soul."
–RHL, *Memories of Hawthorne*

"THE PRINCE OF CONVERSORS," Alcott was an Arch-Transcendentalist philosopher and educator.

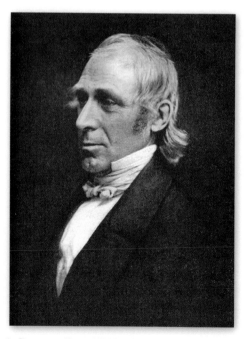

A. Bronson Alcott (1799–1888)

The Salem He Knew

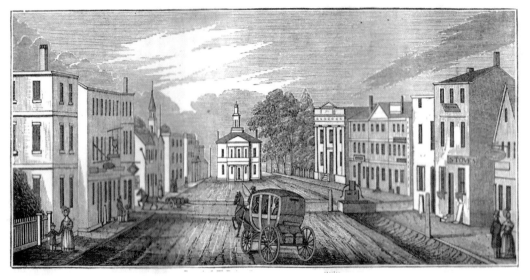

Southern View in the Central Part of Salem (wood engraving by John Warner Barber in *Historical Collections*, 1841)

"Last night…the Old Year…found herself in possession of a few spare moments, and sat
down—of all places in the world—on the steps of our new City Hall."
—*The Sister Years*, 1839/1842

BUILT IN 1836/37, as Barber was gathering information and making wood
engravings for his pictorial history of Massachusetts, the city hall, with its granite
façade, appears on the right side of Court (now Washington) Street next to the trees. The
wood-frame courthouse, designed and built in 1787 by Samuel McIntire (1757–1811),
the native-born, self-taught architect and woodcarver, was in the middle of the street at
that time; it was on the site of the previous courthouse, where the trials for witchcraft
were held in 1692.

The Herbert Street Mansion from Union Street (photograph by Cousins, circa 1890)

"This old town of Salem—my native place, though I have dwelt much away from it both in boyhood and maturer years—possesses, or did possess, a hold on my affections, the force of which I had never realized during my seasons of actual residence there."
—The Scarlet Letter

AFTER THEY LEFT The Old Manse on October 2, 1845, Nathaniel and Sophia returned to Salem with Una and lived for a while in the "old family mansion" with his reclusive mother and two sisters. A corner of his birthplace is depicted at the right of the photograph. In *The House of the Seven Gables*, the author wrote that Salem is a "town noted for its frugal, discreet, well-ordered, and home-loving inhabitants, as well as for the somewhat confined scope of its sympathies; but in which, be it said, there are odder individuals, and, now and then, stranger occurrences, than one meets with almost anywhere else."

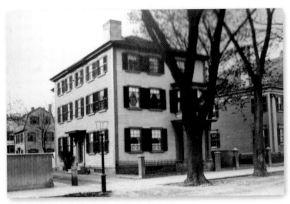

"That house in Bridge Street is unattainable. We may have to stay here [18 Chestnut Street] during the summer, after all. Birds do visit our trees [here], and Una talks incessantly about flowers, birds, and fields. She is a perfect little Idyl of Spring,—a Pastoral Song..." wrote Sophia on April 23, 1847.
—JH, *Nathaniel Hawthorne and His Wife*

Bott-Fabens House, 18 Chestnut Street (photograph by Cousins, circa 1890)

THE HAWTHORNES RENTED this dwelling, with its small rooms, on the corner of Bott's Court for about one year. Julian had been born in Boston on June 22, 1846, while Sophia was at her parents' home at 13 West Street.

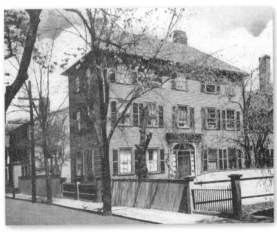

"The house is single in depth, and so we shall bask in sunshine all the winter," noted Sophia.
—JH, *Nathaniel Hawthorne and His Wife*

Peter Edgerley House, 14 Mall Street (postcard, circa 1900)

THE HAWTHORNE FAMILY moved to their third and final Salem abode on Mall Street during late September of 1847, and it was there that Nathaniel wrote *The Scarlet Letter*, *The Snow Image* and other tales in the latter book. For a rental fee of $200 per month, family members were provided with separate living spaces, which included Madame Hathorne (who died on July 31, 1849) and her two daughters, who were delighted to watch the children, Una and Julian, when needed. The three-story, Federal-period dwelling is near the intersection of Bridge and Mall Streets; Nathaniel only had to walk through Salem Common "and down a by-street" to reach his new place of employment at the Custom House on Derby Street.

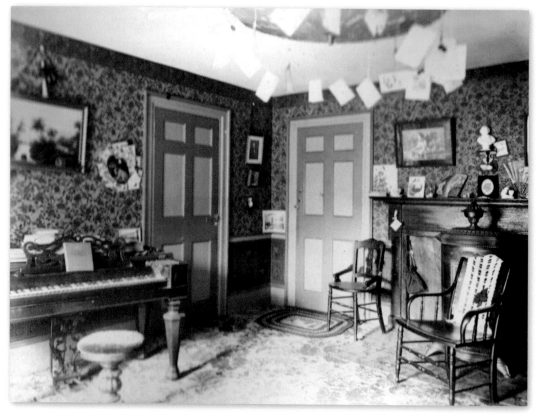

Living room, 14 Mall Street (photograph by Cousins, circa 1890)

Sophia wrote to her mother on September 10, 1847, that she and her husband would live in the middle parlor "because it will save going up and down stairs, both for me and my handmaiden, who will be close at hand in her kitchen across the entry; and because it will save much wood to have no separate nursery, and because there is no other room for a nursery unless I take the drawing-room or the guest-chamber in the third story."
–JH, *Nathaniel Hawthorne and His Wife*

IN VICTORIAN STYLE, as are all the other interior photographs taken by Frank Cousins during the late nineteenth and early twentieth centuries, the living room, when occupied by later residents, featured a piano with carved scrollwork and a cast-iron parlor stove, with bric-a-brac here and there.

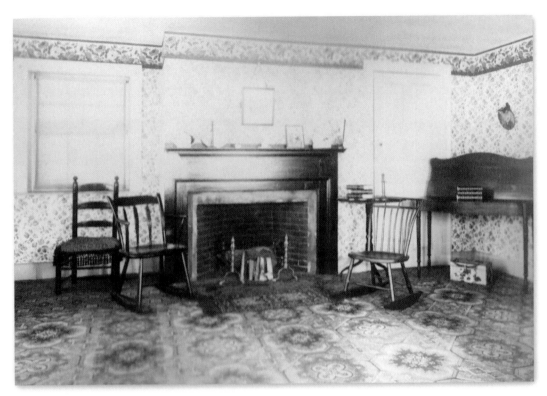

Study, 14 Mall Street (photograph by Cousins, circa 1890)

"My husband's study will be high from all noise, and it will be to me a Paradise of Peace to think of him alone [wearing his flowered dressing gown] *and still, yet within my reach." In the study there is "his secretary, my long ottoman, re-covered with red, and the antique centre table…"* In a letter to her mother, Sophia noted that *"In the evening he is always mine, for then he never wishes to write."*
—JH, *Nathaniel Hawthorne and His Wife*

THE SCARLET LETTER, Hawthorne's first major novel, was penned here after he gave up his position at the Custom House. "You can write your book," Sophia told him when he lamented the disappointment; wisely, she had been putting some money aside for any such eventuality. The family left Salem in 1850, before *The Scarlet Letter* was published, and only returned to the town briefly during the following fourteen years.

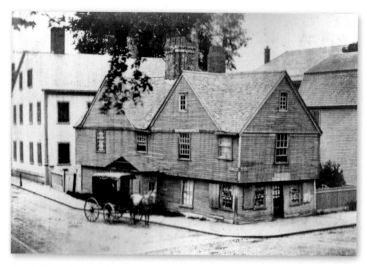

"The timber frame-work of these houses, as compared with those of recent date, is like the skeleton of an old giant, beside the frail bones of a modern man of fashion."
—Main-street

Lewis Hunt House, formerly located at the corner of Washington and Lynde Streets (photograph, circa 1860)

BUILT AROUND 1698, this venerable post-Medieval or First Period dwelling featured a large pilastered chimney and at least three gables and two sides with a jetty, or overhang. The clapboards appear to be original; however, the casement windows had been changed to the sliding sash type when the photograph was taken. Sadly, the picturesque house was razed in 1863.

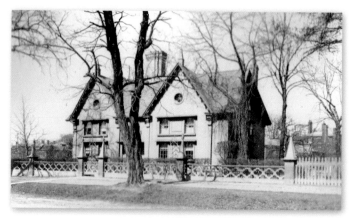

"In our boyhood we used to see a thin, severe figure of an ancient man, time-worn, but apparently indestructible, moving with a step of vigorous decay along the street, and knew him as 'Old Tim Pickering.'"
—A Book of Autographs, 1844

Pickering House, 18 Broad Street (postcard, circa 1905)

BUILT CIRCA 1660, the Pickering House, one of the oldest extant dwellings in Salem, has the distinction of having been home to ten successive generations of the same family. Colonel Timothy Pickering (1745–1829) served in the Revolutionary War and later was in the Cabinets of Presidents George Washington and John Adams. This First Period house had been "Gothicized" by 1841, so Hawthorne would have known it in both forms.

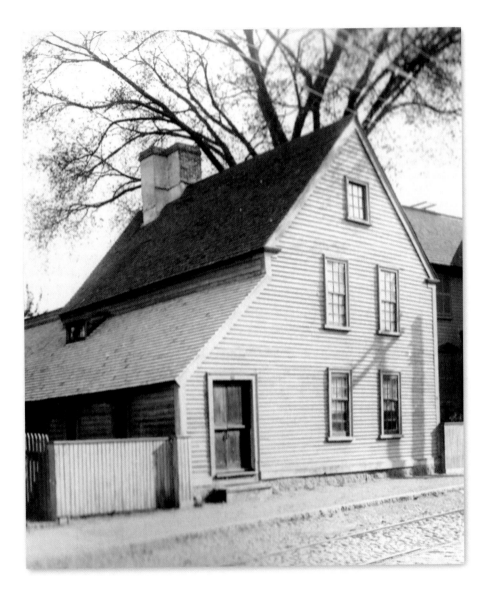

Narbonne House, 71 Essex Street, Salem Maritime National Historic Site (photograph by Cousins, circa 1890)

"We might point to several little [cent] shops…some of them in houses as ancient as that of the Seven Gables; and one or two, it may be, where a decayed gentlewoman stands behind the counter, as grim an image of family pride as Miss Hepzibah Pyncheon herself."
—The House of the Seven Gables

THE LAST RESIDENT of this circa 1672 dwelling was Sarah Narbonne, a seamstress who died at the age of ninety-five in 1890. Along with her daughter, Mary, she operated a cent shop in the lean-to section facing the street.

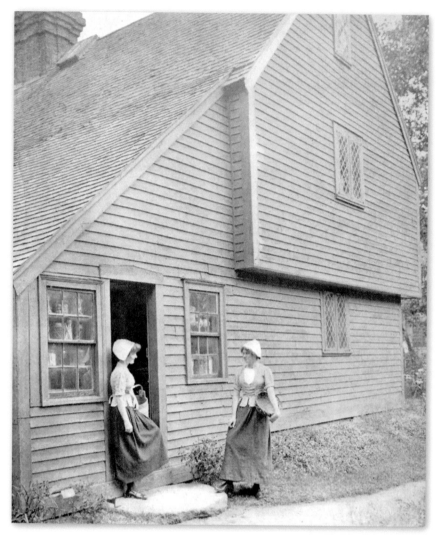

John Ward House, Peabody Essex Museum campus (photograph by Cousins, circa 1890)

"The older dwellings now begin to look weather-beaten, through the effect of the many eastern storms that have moistened their unpainted shingles and clapboards, for not less than forty years."
–Main-street

TWO LOCAL MAIDENS dressed in the Colonial Revival style pause to chat by the open door that leads into the cent shop that historian and early preservationist George Francis Dow (1868–1936) planned for the restoration of the John Ward House between 1910 and 1912. Built circa 1684 for the currier and his family, the dwelling originally stood at 38 St. Peter Street, near the jail on Federal Street where those condemned for witchcraft were incarcerated.

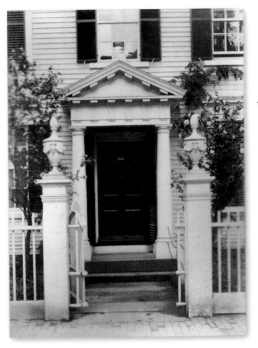

Peirce-Nichols House, 80 Federal Street

"Here comes a lonely rich man; he has built a noble fabric for his dwelling house, with a front of stately architecture and marble floors and doors of precious woods; the whole structure is as beautiful as a dream and as substantial as the native rock."
—The Procession of Life, 1843/1846

NEOCLASSICAL SWAGGED URNS with flame finials adorn the fence of Samuel McIntire's circa 1782 architecturally important Peirce-Nichols House. In ancient civilizations, the urn served as a repository for the cremated remains of the wealthy. Undoubtedly, Hawthorne knew of this historical association with the past.

Gideon Tucker House entrance portico, 129 Essex Street (photograph by Cousins, circa 1890)

"The door of one of the [stately] mansions—an aristocratic edifice, with curtains of purple and gold waving from the windows, is now opened, and down the steps come two ladies…lightly arrayed for a summer ramble…They stand talking, a little while upon the steps, and finally proceed up the street."
—Sights from a Steeple, 1831/1837

SIMILAR elegant semicircular neoclassical entrance porches to that of the circa 1818 Tucker House appear on other nearby brick dwellings, such as the Gardner-Pingree and Andrew-Safford Houses on the grounds of the Peabody Essex Museum, as well as on Chestnut Street, now in the McIntire Historic District.

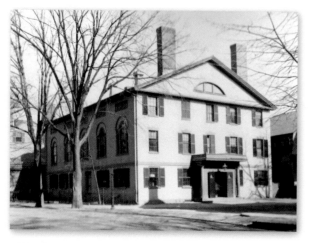

"[Alexander] Hamilton might well be the leader and idol of the Federalists; for he was pre-eminent in all the high qualities that characterized the great men of that party."
—*A Book of Autographs*, 1844

Hamilton Hall, corner of Chestnut and Cambridge Streets (photograph by Cousins, circa 1890)

THE REVOLUTIONARY WAR statesman and the first United States secretary of the treasury, Alexander Hamilton (1755–1804) would have been very pleased to know that this impressive brick public building was named in his honor by local Federalists. The north side of the circa 1805/07 hall features exquisite carvings by Salem's leading architect and woodcarver, Samuel McIntire, including a bas-relief carved eagle, and swags in the paneled areas above the five Palladian windows.

"They [members of the fire engine company] *deluged the roof of* [another] *meeting-house, till the water fell from the eaves in a broad cascade; then the stream beat against the dusty windows like a thunder storm; and sometimes they flung it up beside the steeple, sparkling in an ascending shower about the weather-cock."*
—*Fragments from the Journal of a Solitary Man*, 1837

THE SOUTH CHURCH, with its four tall pilasters and multistory steeple with urn finials designed and carved by McIntire, suffered total devastation in 1903, exactly one hundred years after it was built.

South Church, formerly located at the corner of Chestnut and Cambridge Streets (photograph by Cousins, circa 1890)

Lyceum Hall, 43 Church Street (photograph by Cousins, circa 1890)

"The Rev. Mr. [William Channing] *Gannet* [the Rochester, New York Unitarian minister] *delivered a lecture, at the Lyceum here, the other evening* [in late November of 1848], *in which he introduced an enormous eulogium on whom do you think? Why, on my respectable self!"*
—Nathaniel Hawthorne, who was the corresponding secretary of the Lyceum that year

BRIDGET BISHOP, the first person executed for practicing witchcraft in 1692, owned property on the site of Lyceum Hall. On February 12, 1877, 185 years later, Alexander Graham Bell demonstrated his invention of the telephone by calling from the late nineteenth-century building to his assistant, Thomas Watson, at their laboratory in Boston.

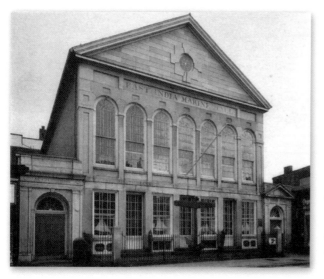

"The other day, having a leisure hour at my disposal, I stepped into a new museum... [along] the sunny sidewalk of our principal thoroughfare."
—A Virtuoso's Collection, 1842/1846

East India Marine Hall, Essex Street Mall (photograph by Cousins, circa 1890)

OWNERS OR CAPTAINS of Salem vessels who circumnavigated Cape Hope or Cape Horn, and who brought back unusual souvenirs of their voyages, prompted the construction of a hall to store and display them. The Salem East India Marine Society (established in 1799) had its museum on the second floor of this imposing Greek Revival–style structure, built in 1824/25. The enormous wrought-iron anchor in front of the granite-faced façade still impresses visitors who seek the museum's treasures.

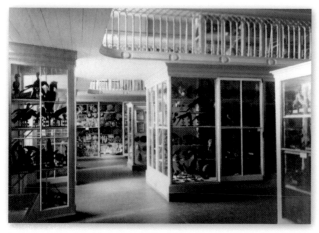

"We now passed to the next alcove of the hall, in which was a multitude of stuffed birds. They were very prettily arranged, some upon the branches of trees, others brooding upon nests, and others suspended by wires so artificially that they seemed in the very act of flight. Among them was a white dove, with a withered branch of olive leaves in her mouth."
—A Virtuoso's Collection

Exhibition room in the former Peabody Museum, Essex Street pedestrian mall (photograph by Cousins, circa 1890)

THE EXHIBIT HAWTHORNE DESCRIBES would have been an earlier one than that pictured above, but likely still in East India Marine Hall.

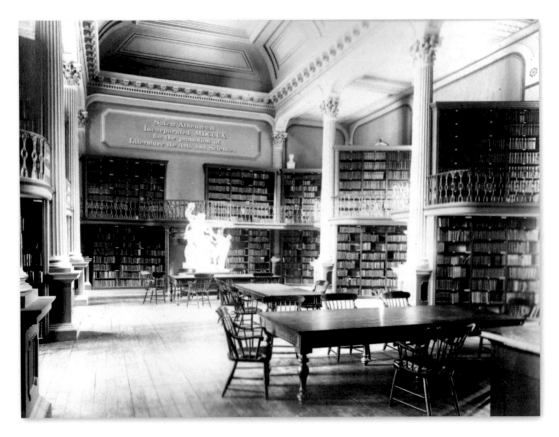

Salem Athenaeum, Plummer Hall, 132 Essex Street (photograph by Cousins, circa 1890)

"It is conceived by many, that Time spends his leisure hours at the [Salem] Athenaeum, turning over the musty leaves of those huge worm-eaten folios, which nobody else has disturbed since the death of the venerable Doctor Oliver."
−*Time's Portraiture,* 1838

BETWEEN 1841 AND 1857, Nathaniel Hawthorne frequented this private proprietary library, which was located at Lawrence Place, 34 Front Street. The Athenaeum's next location was the second floor of architect Enoch Fuller's Plummer Hall, the Italianate brick building constructed in 1856/57, which is now the Phillips Library of the Peabody Essex Museum. A large plaster sculpture of Laocoön, the doomed Trojan priest of Apollo, dominates the reading room, as does the painted sign on the upper level.

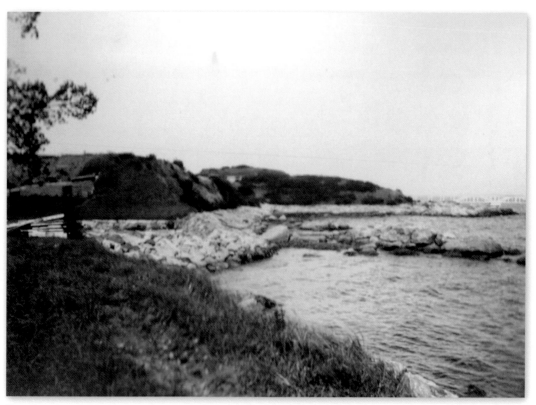

Fort Pickering, Winter Island (photograph by Cousins, circa 1890)

"I scarcely held human intercourse outside of my own family, seldom going out except at twilight, or only to take the nearest way to the most convenient solitude, which was oftenest the seashore."
–JH, *Nathaniel Hawthorne and His Wife*

HAWTHORNE EXPERIENCED a "wretched numbness" while working at the Custom House in Salem, and the "seashore walks and rambles" he took into the countryside gave him a "freshness and activity of thought" he so needed to balance with his work. Fort Pickering, at the tip of Winter Island, and Fort Lee, on the hill near the intersection of Fort Avenue and Memorial Drive, were constructed by the United States government during the Civil War, taking the places of previous forts built in "the Willows."

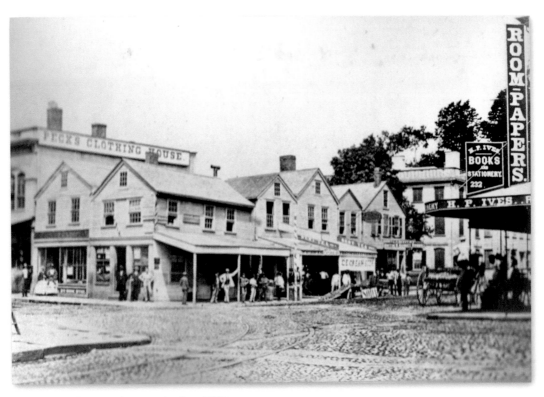

Town House Square (photograph, circa 1872)

*"Old Salem now wears a much livelier expression than when I first beheld her. Strangers
rumble down from Boston* [on the Eastern Railroad, which began service in 1838]
*by hundreds at a time. New faces throng in Essex Street. Railroad hacks and omnibuses rattle
over the pavements. There is a perceptible increase of oyster shops, and other establishments for
the accommodation of a transitory diurnal multitude."*
–The Sister Years, 1839

A CLUSTER OF GABLE-END-TO-THE-STREET wood-frame buildings, some of which
may have been residences previously, had been converted to first-floor businesses by
the mid-nineteenth century. Peck's Clothing House and H.P. Ives Books and Stationery
emporiums were larger by far than the other retailers, as were their trade signs.

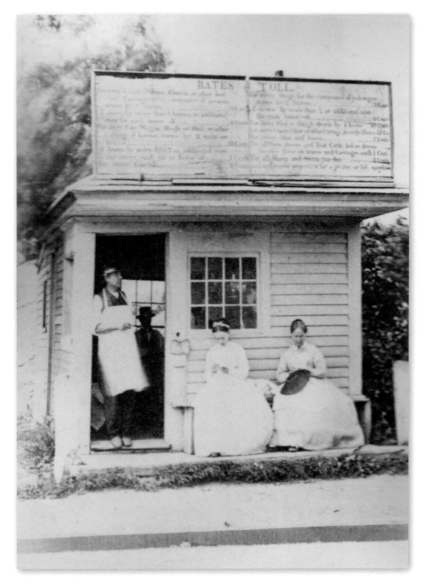

Toll House, Highland Avenue, Salem and Boston Turnpike (photograph by Cousins, circa 1890)

"Over the door is a weather-beaten board inscribed with the rates of toll, in letters so nearly effaced that the gilding of the sunshine can hardly make them legible. Beneath the window is a wooden bench, on which a long succession of weary wayfarers have reposed themselves."
–The Toll-Gatherer's Day, 1837/1842

ON ONE OF HIS MANY perambulations beyond the center of the town, Hawthorne encountered "our good old toll-gatherer, glorified by the early sunbeams."

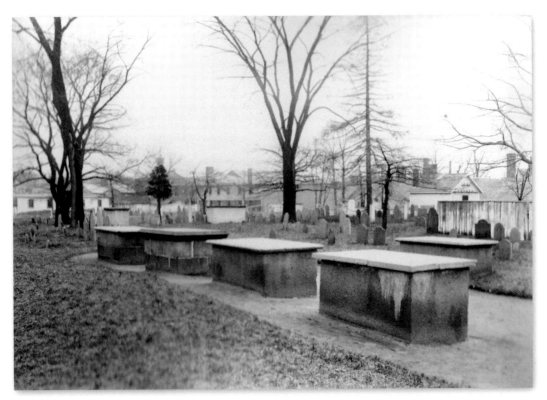

Charter Street Cemetery, "the Old Burial Place" (photograph by Cousins, circa 1890)

"The elaborate solemnities of funerals were in accordance with the somber character of the times. In cases of ordinary death, the [newspaper] *printer seldom fails to notice that the corpse was 'very decently interred.'"*
–*Old News,* 1835/1852

THE OLDEST BURIAL GROUND in Salem (established in 1637) contains the gravestones of notable citizens; one of the earliest slate markers is that of Doraty Cromwell, who died in 1673. Hawthorne knew this final resting place well; at least eight members of his family were interred there, including his grandparents, Captain Daniel and Rachel Hathorne, two of their daughters and the infamous "witchcraft judge," Colonel John Hathorne, Esq., who departed this life in 1717. The Hathorne gravestones are located diagonally a few rows to the left of the rear tabletop, or box, tomb. An addition to the cemetery was made in 1767, and the following phrase by Hawthorne might apply to some of those buried thereafter: "All that I had accomplished—all that I planned for future years—has perished by one common ruin, and left only this heap of embers…And what remains? A weary and aimless life…and at last an obscure grave, where they will bury and forget me!" (Oberon speaking about himself in *The Devil in Manuscript,* 1835/1852)

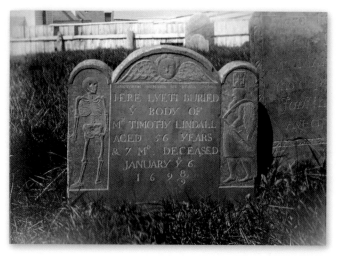

"The burial train glides slowly before us, as we have seen it represented in the wood-cuts of that day, the coffin, and the bearers, and the lamentable friends, trailing their long black garments, while grim Death, a most mis-shapen skeleton, with all kinds of doleful emblems, stalks hideously in front."
—*Old News*

Timothy Lindall gravestone, 1698/99, Charter Street Cemetery (photograph by Cousins, circa 1890)

THE MOST GRAPHIC SLATE gravestone in the burying ground is that of Timothy Lindall, who was a merchant and prominent citizen. Flanking the inscription are a well-delineated skeleton and Father Time, holding a scythe and balancing an hourglass on his head. Nearby, a frightful winged skull appears on the 1688 Nathaniel Mather gravestone, and only a decade later, a cherubic head, or "soul effigy," with wings was carved onto the Lindall tombstone, heralding a less gruesome image of death.

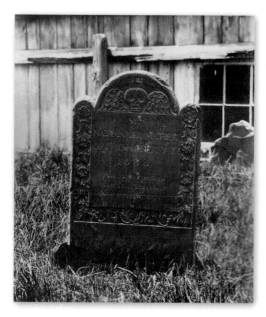

"It is good to die in early youth. Had I lived out three-score years and ten, or half of them, my spirit would have been so earth-encrusted, that centuries might not have purified it for a better home than the dark precincts of the grave."
—*Graves and Goblins*

THE INSCRIPTION ON THE GRAVESTONE of Cotton Mather's younger brother, Nathaniel—"An Aged person/that had seen but/Nineteen Winters/in the World"—may pertain to his precocious knowledge. Hawthorne wrote that the youth was mentioned in Cotton Mather's *Magnalia Christi Americana* (1702) "as a hard student, and of great promise."

Nathaniel Mather gravestone, 1688, Charter Street Cemetery (photograph by Cousins, circa 1890)

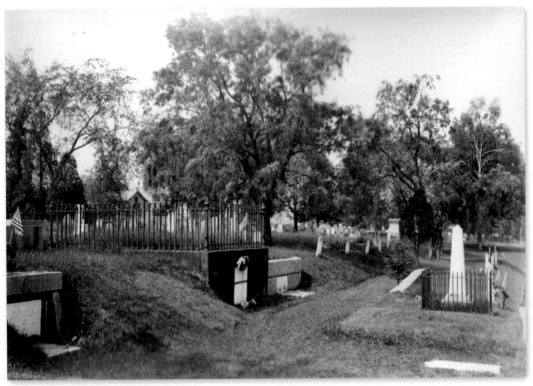

Broad Street Cemetery (photograph by Cousins, circa 1890)

"On the side of the opposite hill was the grave-yard, sloping towards the farther extremity of the village. The sun shone as cheerfully there as on the abodes of the living, and showed all the little hillocks and the burial stones, white marble or slate, and here and there a tomb, with the pleasant grass about them all."
—*Fragments from the Journal of a Solitary Man*

SALEM'S SECOND OLDEST burying ground was established in 1655. In *Alice Doane's Appeal* (1835), Hawthorne writes about family tombs giving up their inhabitants: "All, in short, were there; the dead of other generations, whose moss-grown names could scarce be read upon their tomb stones, and their successors, whose graves were not yet green; all whom black funerals had followed slowly thither, now re-appeared where the mourners left them."

Hawthorne's Witchcraft Fascination

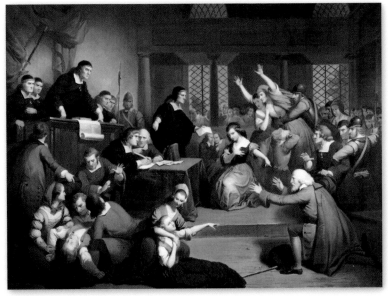

The Trial of George Jacobs, August 5, 1692 (oil painting on canvas by Tompkins H. Matteson, 1855; courtesy of the Peabody Essex Museum)

"Is not this characteristic wonderfully perceptible in our spectral representation of his person?"
–Main-street

COLONEL JOHN HATHORNE, the author's vituperative ancestor, is one of the magistrates depicted in this Victorian melodrama of the witchcraft trial of the elderly George Jacobs, shown on bended knee with a cane by his side. Spectral evidence, as supposedly witnessed by the people who accused their innocent neighbors of malfeasance, was highly regarded by court officials in the condemnation and execution in 1692 of 19 men and women by hanging, and of 1 other elderly man, Giles Corey, being pressed to death. In that frightful year, 153 people from the greater Salem area were crowded into jails awaiting examination. The hysteria finally ceased in October after the wife of Royal Governor Sir William Phips was accused; he then quickly dissolved the Court of Oyer and Terminer ("to hear and determine").

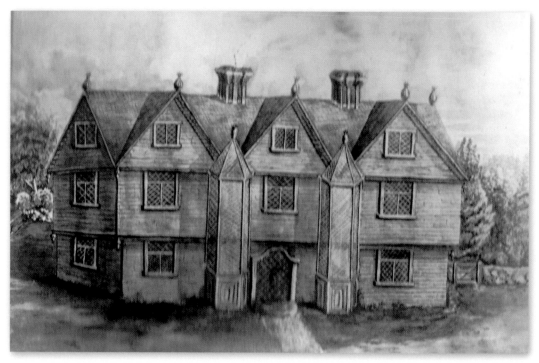

Emmanuel Downing House, 136 Essex Street, Salem (watercolor by Samuel Bartoll, 1819; photograph by Cousins, circa 1890)

"And there, at that stately mansion [Captain Gardner's], *with its three peaks in front, and its two little peaked towers, one on either side of the door."*
—Main-street

JUDGE JONATHAN CORWIN was the son of merchant George Corwin and the uncle of "witchcraft sheriff" George Corwin. The magistrate "seems to have been an austere, painstaking, conscientious man, liable to become the victim of lamentable prejudices and delusions, but capable, also, of bitterly repenting his errors," wrote Julian Hawthorne. The architecturally similar house where Judge Corwin resided also featured Gothic finials on the main gables, and a projecting two-story enclosed porch with arched batten door. When Nathaniel Hawthorne knew the house, it had been remodeled during the mid-eighteenth century with a gambrel roof.

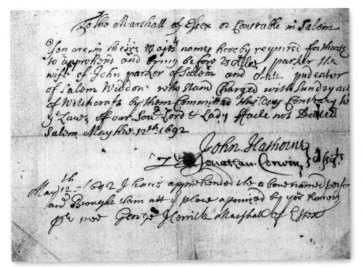

The town constable [George Corwin]…"loves his business…and puts his soul into every stroke [with his whip], zealous to fulfill the injunction of Major Hawthorne's [sic] warrant, in the spirit and to the letter."
—Main-street

Warrant for the arrest of Alice Parker and Ann Pudeator, May 12, 1692 (Courtesy of the Peabody Essex Museum)

THE SIGNATURES of John Hathorne and Jonathan Corwin are quite discernable in this historic document of 1692.

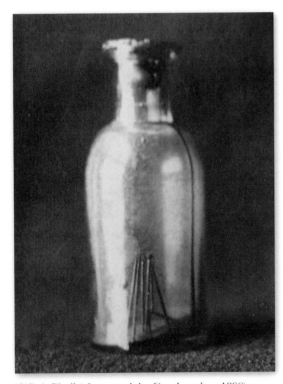

"They, or their spectral appearances, have stuck pins into the Afflicted Ones, and thrown them into deadly fainting-fits with a touch, or but a look."
—Main-street

MARY PARKER WAS ACCUSED of witchcraft by Mary Warren when "a pin run through her hand [caused] blood runeing [sic] out of her mouth." It is more than likely that the several pins in this small, clear glass bottle actually fastened together some of the original witchcraft documents after they had been collected for posterity.

"Witch Pins" (photograph by Cousins, circa 1890)

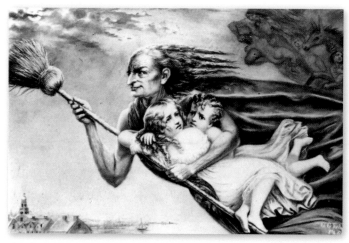

"'The little baggage [Pearl, the elf-child in *The Scarlet Letter*] *hath witchcraft in her, I profess,' said he* [Pastor John Wilson] *to Mr.* [Arthur] *Dimmesdale. 'She needs no old woman's broomstick to fly withal!'"*

—*The Scarlet Letter*

A Witch Stealing Children (postcard of the painting by G.G. Fish, circa 1865; courtesy of the Peabody Essex Museum)

A MANNISH-LOOKING, balding witch with pronounced features clasps two frightened children as they fly over Salem Town, with an ominous apocalypse following close behind. Hawthorne named one of the family's cats "Beelzebub" (the Devil), which may have been black in color with yellow eyes.

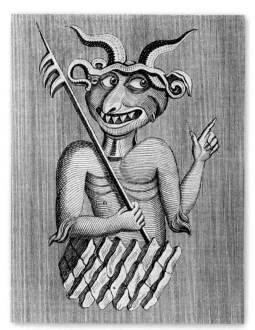

"But close behind him [Peter Goldthwaite], *with a fiendish laugh on his features, appeared a figure with horns, a tufted tail, and a cloven hoof."*

—*Peter Goldthwaite's Treasure, 1838/1842*

GOD'S FALLEN ANGEL, Satan, has many demonic titles, including "the Father of Lies," "Old Nick" and the "Prince of Darkness." Cotton Mather and Samuel Wardwell, two Boston clergymen, called him "the black Man" and branded him "his Satanic majesty" and the accused witches "night-birds."

Satan the Seducer (untitled wood engraving by an unidentified artist in James Thacher's *An Essay on Demonology, Ghosts and Apparitions, Also, An Account of the Witchcraft Delusion at Salem in 1692*, 1831)

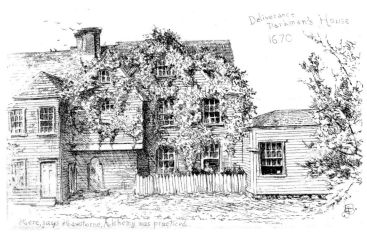

"Here, says Hawthorne, Alchemy was practiced."
—*Passages from the American Note-Books,* 1835–1853

Deliverance Parkman's House, 1670 (etching by Lewis Jesse Bridgman, circa 1892)

PICTURESQUE DELIVERANCE PARKMAN'S HOUSE, formerly located on the eastern corner of Essex and North Streets, had a lush vine engulfing most of the clapboard-frame façade. Hawthorne noted that a brick turret had been erected "wherein one of the ancestors of the present occupants used to practice alchemy." Other alchemists were active in Salem then, including "one who kept his fire burning seven weeks, and then lost the elixir by letting it go out." The rear exterior of The House of Seven Gables was supposedly modeled on that of the Parkman house.

"Then, here comes the worshipful Captain [George Corwin] *Curwen, Sheriff of Essex* [County]*, on horseback, at the head of an armed guard, escorting a company of condemned prisoners from the jail to their place of execution on Gallows Hill. The witches! There is no mistaking them! The witches!"*
—*Main-street*

Gallows Hill (photograph by Cousins, circa 1890)

HISTORIANS, PAST AND PRESENT, have not determined the exact location of the nineteen executions by hanging that took place on the rocky summit. One plausible spot is the hillside area near the intersection of Boston and Bridge Streets.

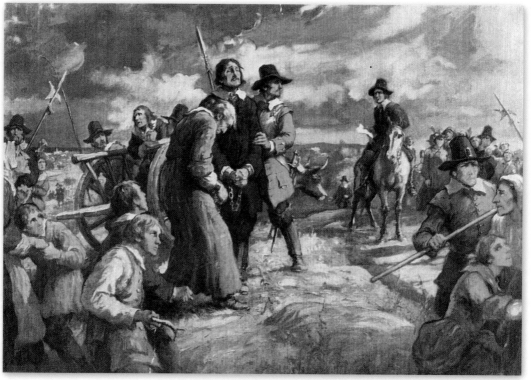

Witchcraft Victims on the Way to the Gallows (illustration in a supplement to the *Boston Herald* by F.C. Yohn, May 14, 1930)

"For this was the field where superstition won her darkest triumph; the high place where our fathers set up their shame, to the mournful gaze of generations far remote. The dust of martyrs was beneath our feet. We stood on Gallows Hill."
—*Alice Doane's Appeal*, 1835

BOSTONIAN THOMAS BRATTLE wrote that five of the victims "forgave their accusers…and seemed to be very sincere, upright, and sensible of their circumstances on all accounts… [which was] very affecting and melting to the hearts of some considerable Spectatours [*sic*]."

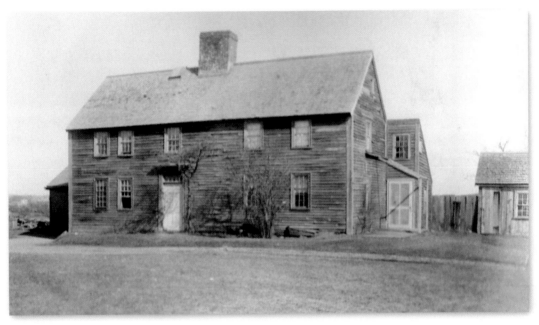

George Jacobs Sr. House, formerly located on Water Street in Danversport (photograph by Cousins, circa 1890)

"There is old George Jacobs, known hereabouts, these sixty years, as a man whom we thought upright in all his way of life [and Satan] beheld this forlorn old man, to whom life was a sameness and a weariness, and found the way to tempt him. So the miserable sinner was prevailed with to mount into the air, and career among the clouds; and he is proved to have been present at a witch-meeting as far off as Falmouth [Maine], on the very same night that his next neighbors saw him, with his rheumatic stoop, going in at his own door."
—Main-street

JACOBS OWNED THIS CIRCA 1658 FARMHOUSE and it remained in the family until around 1920. Sheriff Corwin seized the property after Jacobs was imprisoned for supposedly being a wizard; he also took Mrs. Jacobs's wedding ring, forcing her to purchase provisions from him and then to accept donations of food from her neighbors. George Jacobs was hanged on Gallows Hill on August 19, 1692, after he was quoted as having exclaimed, "Well burn me, or hang me, I will stand in the truth of Christ."

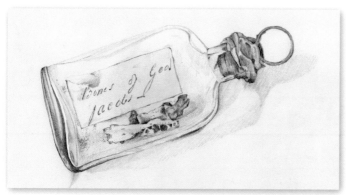

"At once, the truth fell on my miserable spirit, and crushed it to the earth, among dead men's bones and mouldering dust, groaning in cold and desolate agony."
—*Graves and Goblins*

Bones of George Jacobs (pencil on paper by this author, 1971)

THE SMALL, CLEAR GLASS BOTTLE with bright red sealing wax supposedly contains two finger bones, a coffin nail and a pin, which were excavated by Joseph Orne and Benjamin Goodhue of Salem on the former property of the executed "wizard." The handwritten paper label was glued to the outside of the bottle to identify the gruesome contents, presented to the Essex Institute in 1902.

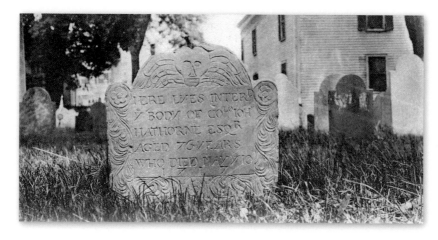

Colonel John Hathorne's gravestone, the Burying Point, Charter Street, Salem (photograph by Cousins, circa 1890)

William Hathorne's son "inherited the persecution, spirit, and made himself so conspicuous in the martyrdom of the witches, that their blood may fairly be said to have left a stain upon him. So deep a stain, indeed, that his dry old bones, in the Charter Street burial-ground, must still retain it, if they have not crumbled utterly to dust!"
—*The Scarlet Letter*

NATHANIEL HAWTHORNE WROTE in his *Note-Books* on July 4, 1837, "The [1717] stone is sunk deep into the earth, and leans forward, and the grass grows very long around it…Other Hathornes lie buried in a range with him on either side."

The Custom House and The Scarlet Letter

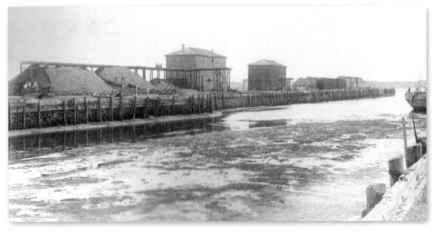

Derby Wharf, Derby Street, Salem (photograph by Cousins, circa 1890)

"In my native town of Salem, at the head of what, half a century ago, in the days of Old King [Elias Hasket] *Derby, was a bustling wharf…but which is now burdened with decayed wooden warehouses, and exhibits few or no symptoms of commercial life…at the head, I say, of this dilapidated wharf, which the tide often overflows…here, with a view from its front windows…and thence across the harbour, stands a spacious edifice of brick* [the town's newest and last Custom House].*"*
—*The Scarlet Letter*

THE LONG WHARF that the Derby family had constructed opposite the Custom House was begun in 1762, and it was extended in 1806 to its half-mile length with a jog at the end. Bustling with unprecedented activity during the Federal period (except when President Jefferson's embargo was enacted) this, and the approximately fifty wharves along the harbor, witnessed the arrival of ships from distant ports; they returned with various goods, including those of Asian splendor for the parlors of the wealthy as well as exotic spices for the preparation of meals. When Nathaniel Hawthorne was appointed surveyor of the Port of Salem in 1846, the wharf looked much as it does in this photograph.

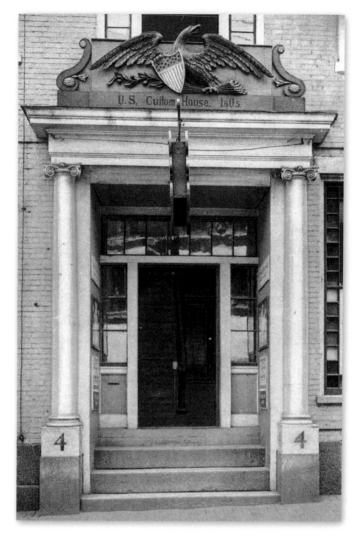

Doorway of Old Custom House, 4–10 Central Street (postcard, 1906; courtesy of the Schier collection)

"In 1801, one hundred and seventy-one vessels cleared through the Custom House and two hundred and twelve arrived…By 1807 it had risen to more than ten a week and the amount of labor involved in loading and unloading, repairing and putting the ships in order, and provisioning them for long voyages was very great."
–James Duncan Phillips, *Salem and the Indies,* 1947

THE UNITED STATES CUSTOM SERVICE in Salem was located in this three-story brick commercial building between 1805–07 and 1813–19. Nathaniel Hawthorne was not employed by the government at this time. Samuel McIntire possibly designed the structure; he is known to have carved the magnificent signboard with bas-relief eagle, in the collection of the Peabody Essex Museum.

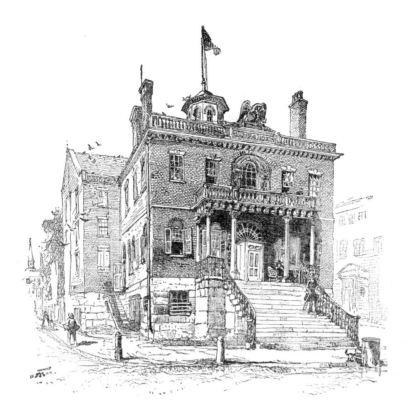

Salem Custom House, 178 Derby Street (pen-and-ink drawing by Henry Fenn in *The Century Magazine*, 1888)

"Its front is ornamented with a portico of half a dozen wooden pillars, supporting a balcony, beneath which a flight of wide granite steps descends towards the street. Over the entrance hovers an enormous specimen of the American eagle, with outspread wings, a shield before her breast, and, if I recollect aright, a bunch of intermingled thunderbolts and barbed arrows in each claw."
–The Scarlet Letter

THE INFLUENCE OF SAMUEL MCINTIRE'S Federal-period commercial and residential buildings can be seen in the 1819 imposing Custom House, with its rich detail and Flemish-bond brickwork. The architect is not known; however, four of McIntire's contemporaries were involved in its construction. The original carved and gilded pine eagle (the present one being an exact reproduction) was made in 1826 by Joseph True, McIntire's woodcarving successor in Salem. The octagonal Italianate cupola was added in 1853. In April of 1846, Nathaniel Hawthorne was appointed by President James K. Polk to be surveyor of the Port of Salem at an annual salary of $1,200, for which he worked three and a half hours per day. Hawthorne was unexpectedly dismissed from the Custom House in the summer of 1849. He was removed from office on false charges, made mainly by local members of the Whig Party.

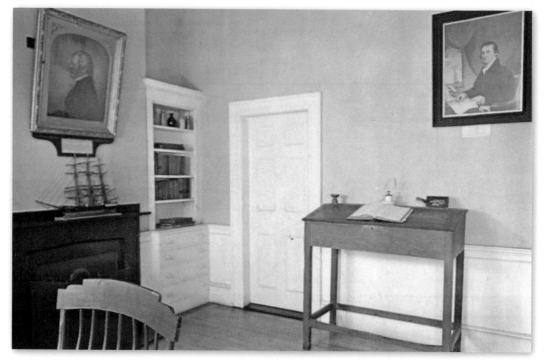

Custom collector's office, Custom House (postcard, circa 1950; courtesy of the Salem Maritime National Historic Site)

> *"Meanwhile, there I was, a Surveyor of the Revenue, and, so far as I have been able to understand, as good a Surveyor as need be."*
> *—The Scarlet Letter*

HAWTHORNE WROTE in the introduction to his first novel, "So little adapted is the atmosphere of a Custom-House to the delicate harvest of fancy and sensibility, that, had I remained there through ten Presidencies yet to come, I doubt whether the tale of 'The Scarlet Letter' would ever have been brought before the public eye." A black-and-white photograph of Elias Hasket Derby's oil portrait hangs above the desk where Hawthorne worked; he casually scratched his surname on the lid. The hand stencil staff used to mark incoming cargoes is on the pine desk "among the inkstands, paper-folders, and mahogany rulers." An oil portrait of Major Joseph Hiller, the first American collector of customs, is above the three-masted ship model.

Permit to land cargo, May 16, 1848 (author's collection)

"Did you ever behold such a vile scribble...My chirography always was abominable, but now it is outrageous."
—Passages from the American Note-Books, 1835–1853

WILLIAM MOORE paid his customs bill for sixteen cords of wood shipped from Cornwallis, Nova Scotia, on the schooner *John*, as witnessed and signed by Zachariah Burchmore, the clerk; Joseph Linton Waters, the naval officer; and by Nathaniel Hawthorne, the surveyor, whose partially blurred signature is in the lower left corner. In *The Scarlet Letter* Hawthorne wrote, "In the Custom-House, as before in the Old Manse, I had spent three years—a term long enough to rest a weary brain; long enough to break off old intellectual habits, and make room for new ones."

SALEM. 1847. N. HAWTHORNE SUR.

"No longer seeking nor caring that my name should be blazoned abroad on title-pages, I smiled to think that it had now another kind of vogue. The Custom-House marker imprinted it, with a stencil and black paint, on pepper-bags, and baskets of anatto, and cigar-boxes, and bales of all kinds of dutiable merchandise, in testimony that these commodities had paid the import, and gone regularly through the office."
—The Scarlet Letter

Reduced facsimile of Hawthorne's stamp as surveyor (courtesy of the Salem Maritime National Historic Site)

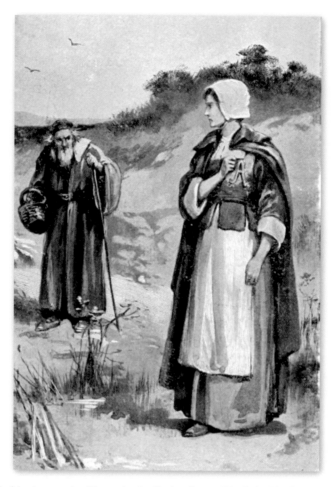

Hester and the Physician (watercolor illustration by Evelyn Stuart Hardy in *The Scarlet Letter*, circa 1900)

"Her mother had accosted the physician."
—*The Scarlet Letter*

"BUT THE OBJECT that most drew my attention in the mysterious package [which Hawthorne discovered in a second-story room of the Custom House] was a certain affair of fine red cloth, much worn and faded. There were traces about it of gold embroidery... wrought...with wonderful skill of needlework...[it] assumed the shape of a letter. It was the capital letter A...My eyes fastened themselves upon the old scarlet letter, and would not be turned aside. Certainly there was some deep meaning in it most worthy of interpretation." The first American novel to deal with adultery, *The Power of Sympathy*, was written by William Hill Brown in 1789. In seventeenth-century Boston, Mary Latham was executed in 1644, along with her lover, James Button, for adultery. While in Salem, Hester Craford was given a harsh whipping in 1688 for fornication and bearing an illegitimate child. Eleven years later, in 1699, also in the same town, a woman had to wear the letter "A" on her clothing for the sin of adultery.

The House of the Seven Gables

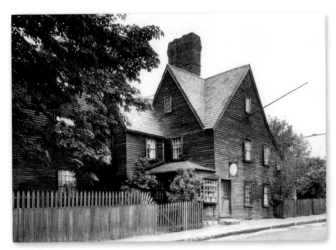

"Half-way down a by-street of one of our New England towns [Salem] stands a rusty wooden house, with seven acutely peaked gables, facing towards various points of the compass, and a huge, clustered chimney in the midst."
—The House of the Seven Gables

Turner-Ingersoll Mansion, 54 Turner Street (early twentieth-century photograph; courtesy of The House of the Seven Gables)

THE WORD "ROMANCE" was used by Nathaniel Hawthorne in the first sentence to the preface of *The House of the Seven Gables*, which was completed on January 26, 1851, and published shortly thereafter. He conceived the plot of his only Salem-based romance from visits with his cousin, Susannah Ingersoll, and incorporated aspects of his ancestor's involvement in the witch trials to craft one of his most popular and widely read novels. The earliest section of the dwelling was built in 1668 for Captain John Turner, who upon his death owned six properties and five vessels. In 1676 the house was enlarged, and in 1710 many rooms were made more fashionable with up-to-date Georgian paneling; at the same time the casement windows were changed to double-hung, sliding sash. The third Turner with the same first name, but evidently not with the same financial wisdom, unfortunately lost the family property. In 1780, it was acquired through auction by Captain Samuel Ingersoll, Susannah's father; in 1811 she later inherited the property. In 1883, before it became converted to a tenement house, Henry Upton bought the historic dwelling, and later opened it to visitors for a nominal fee.

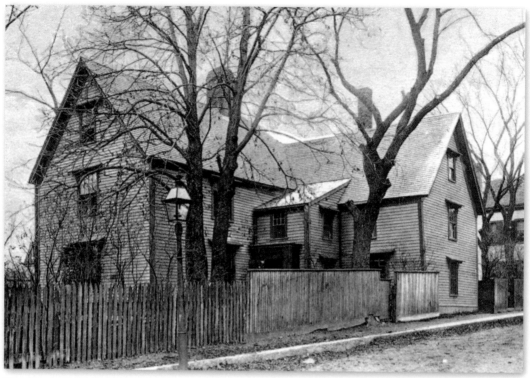

The House of the Seven Gables (photograph by Cousins, circa 1890)

"The impression of its actual state, at this distance of a hundred and sixty years, darkens
inevitably through the picture which we would fain give of its appearance on the morning when
the Puritan magnate [Colonel Pyncheon] bade all the town to be his guests."
—*The House of the Seven Gables*

INTERESTINGLY, when Hawthorne penned this sentence, he was off by one year from the infamous date of 1692, when the Salem witchcraft trials and executions took place, if he was basing the 160 years from the date of his novel's publication in 1851! Also, when Hawthorne visited the dwelling, the exterior had Victorian architectural features layered over the 1780 modest Federal appearance given to it by Captain Ingersoll.

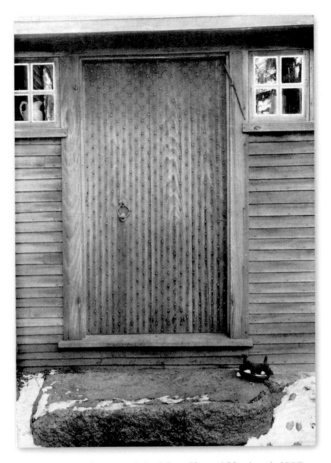

Batten door (photograph by Mary Harrod Northend, 1926)

"So young [Matthew] Maule went straight to the principal entrance, beneath a portal of carved oak, and gave such a peal of the iron knocker that you would have imagined the stern old wizard himself to be standing at the threshold."
– *The House of the Seven Gables*

A SECTION OF THE ORIGINAL BATTEN DOOR, with its diamond-shaped design produced by many rose head nails, is displayed in the garret of the house. Caroline O. Emmerton (1866–1942), a local philanthropist, realized that the association with Nathaniel Hawthorne might be capitalized upon if the house were restored to look as it appeared in the novel. Hoping the revenue would help with her settlement house project, "Miss Emmerton" purchased the property in the spring of 1908 and embarked upon its restoration with the noted Boston-based Colonial Revival architect Joseph Everett Chandler (1864–1945). The House of the Seven Gables, with its four missing gables reconstructed, was opened to inquisitive Salemites and tourists in 1910.

Phoebe Arriving at the Seven Gables (postcard, circa 1915; courtesy of the Schier collection)

"If you [Hawthorne] *pass Hepzibah's cent-shop, buy me a Jim Crow (fresh) and send it to me by Ned Higgins* [the local boy who frequented her shop for animal-shaped gingerbread cookies].*"*
 letter from Melville to Hawthorne

WHILE LIVING IN PITTSFIELD, MASSACHUSETTS, Herman Melville included this sentence in a congratulatory letter to Hawthorne before he and his family left Salem in early 1851 and moved to the Berkshires. In another long letter to his new friend, Melville also praised Hawthorne for his "power of blackness."

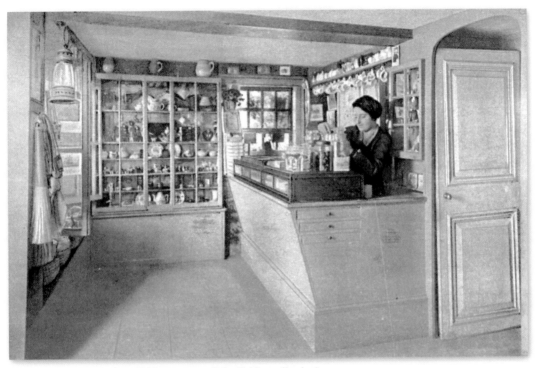

Cent shop (postcard, circa 1915; courtesy of the Schier collection)

"We must renew our stock, Cousin Hepzibah!" cried the little saleswoman [Phoebe]. *"The gingerbread figures are all gone, and so are those Dutch wooden milkmaids, and most of our other playthings. There has been constant inquiry for cheap raisins, and a great cry for whistles, and trumpets, and jew's-harps; and at least a dozen little boys have asked for molasses candy."*
—The House of the Seven Gables

APPARENTLY, there was never a cent shop in the historic house, but one was added during the restoration and was stocked with many of the objects described above. "Miss Emmerton" knew that visitors expected to see a cent shop at "the Gables"—and perhaps even see Hepzibah herself!

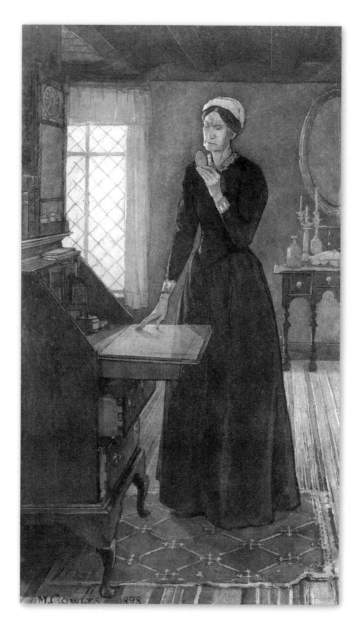

"Can it have been an early lover?" (illustration by Mildred L. Cowles, in *The Complete Works of Hawthorne*, 1898, Fireside Edition, vol. III, 1909)

HEPZIBAH HAS A MORE GRACEFUL and less frightening appearance than her portrayal as "a gaunt, sallow, rusty-jointed maiden, in a long-waisted silk gown, and with the strange horror of a turban on her head!" Midway through the novel, hoping to attend a church service, Hepzibah's "pale, emaciated, age-stricken" brother Clifford suddenly turned to her and said with deep sadness, "It cannot be…it is too late…We are ghosts! We have no right among human beings—no right anywhere, but in this old house, which has a curse on it, and which, therefore, we are doomed to haunt."

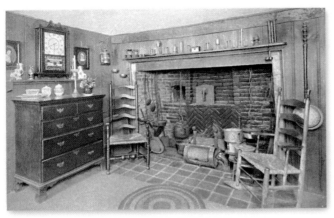

"Hepzibah gladly assenting, the kitchen was soon the scene of savory preparation. Perchance, amid their proper element of smoke, which eddied forth from the ill-constructed chimney, the ghosts of departed cookmaids looked wonderingly on, or peeped down the great breadth of the flue, despising the simplicity of the projected meal, yet ineffectually pining to thrust their shadowy hands into each inchoate dish."

—The House of the Seven Gables

Kitchen (postcard, circa 1915; courtesy of the Schier collection)

THE KITCHEN is in the original section of the house, and its 1910 Colonial Revival appearance has been retained, while other rooms in the dwelling represent the Georgian style.

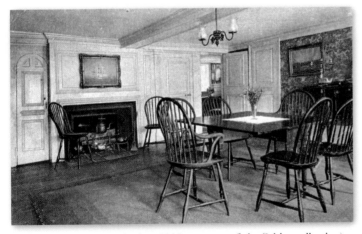

"There, after a glass of brandy and water, and a mutton-chop, a beefsteak, a broiled fowl, or some such hasty little dinner and supper all in one, he [Judge Pyncheon] had better spend the evening by the fire-side."

—The House of the Seven Gables

Dining room (postcard, circa 1915; courtesy of the Schier collection)

THE DINING ROOM was used as a family room in the seventeenth century, when it would have been referred to as the "hall." Georgian raised paneling and two China trade oil paintings of the ports of Canton and Macao are noteworthy in this view. The narrow arched door to the left of the fireplace is actually the entrance to the "secret staircase" that Joseph Chandler, under Caroline Emmerton's direction, had built around the chimney to delight tourists who enjoy the mysterious, steep ascent to "Clifford's room."

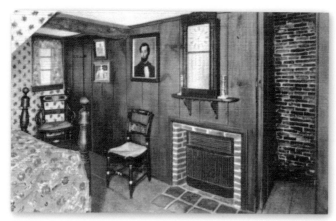

"Clifford commonly retired to rest, thoroughly exhausted, while the sunbeams were still melting through his window curtains, or were thrown with late luster on the chamber wall."
—The House of the Seven Gables

"Clifford's room" (postcard, circa 1945; courtesy of the Schier collection)

THE DOOR in the small chamber is open to show part of the brick chimney and the landing of the "secret staircase." Due to its poor condition, the original, impressive chimney was removed by Henry Upton. A portrait of Horace Conolly, Miss Ingersoll's "adopted" son, is shown near the faux fireplace.

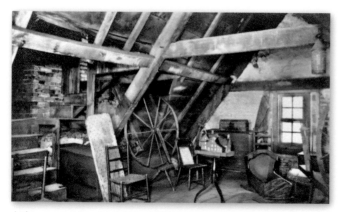

"Under that roof, through a portion of three centuries [Holgrave tells Phoebe], *there has been perpetual remorse of conscience, a constantly defeated hope, strife amongst kindred, various misery, a strange form of death, dark suspicion, unspeakable disgrace."*
—The House of the Seven Gables

Attic or garret (postcard, circa 1915; courtesy of the Schier collection)

THE ROUGH, UNFINISHED interior roof and gable construction contrasts with the off-white horsehair plaster and visible sections of "noggin," used to insulate the wall. Some of the original pine floorboards measure slightly under twenty-four inches in width. At one time during the nineteenth century, three indentured white servants lived in the garret, without heat! On the candle stand is a model of the house, which can be taken apart to show visitors how the structure has been remodeled over the years.

"Holgrave's studio" in the garret (photograph by Cousins, circa 1890)

> "[Hepzibah] *unbolted a door, cobwebbed and long disused, but which had served as a former medium of communication between her own part of the house and the gable where the wandering daguerreotypist had now established his temporary home."*
> —The House of the Seven Gables

"SCUTTLE STAIRS" lead to the skylight and the adjacent studio area where Holgrave kept "a book, face downward, on the table, a roll of manuscript…a newspaper, some tools of his present occupation, and several related daguerreotypes [which] conveyed an impression as if he were close at hand," thought Hepzibah.

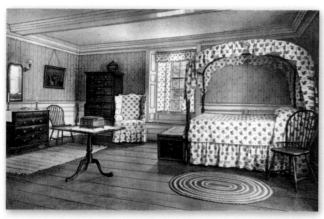

"The shadows of gloomy events that haunted the else lonely and desolate apartments; the heavy, breathless scent which death had left in more than one of the bedchambers, ever since his visits of long ago—these were less powerful than the purifying influence scattered throughout the atmosphere of the household by the presence of one youthful, fresh and thoroughly wholesome heart [that of Phoebe Pyncheon]."
—*The House of the Seven Gables*

The great chamber (postcard, circa 1915; courtesy of the Schier collection)

INITIALLY, BRAIDED RUGS were scattered throughout "period rooms" when they were set up during the Colonial Revival years. These colorful, and almost always oval, rugs, however, were unknown before that time.

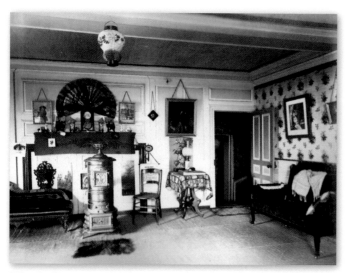

"Phoebe Pyncheon slept, on the night of her arrival, in a chamber that looked down on the garden of the old house… [and in the morning] *a glow of crimson light came flooding through the window, and bathed the dingy ceiling and paper hangings in its own hue."*
—*The House of the Seven Gables*

"Phoebe Pyncheon's room" (photograph by Cousins, circa 1890)

THE FURNITURE and colorful decorative accessories owned by the Upton family were assembled to give what had been "Phoebe's room" in the novel a cozy appearance.

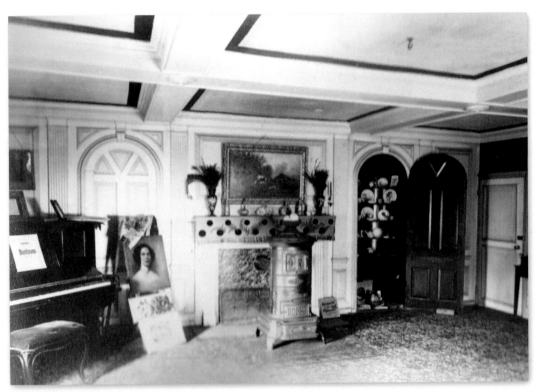

Parlor (photograph by Cousins, circa 1890)

"On returning into Hepzibah's department of the house, she [Phoebe] found the low-studded parlor so dim and dusky that her eyes could not penetrate the interior. She was distinctly aware, however, that the gaunt figure of the old gentlewoman was sitting in one of the straight-backed chairs, a little withdrawn from the window, the faint gleam of which showed the blanched paleness of her cheek, turned sideways toward a corner."
—*The House of the Seven Gables*

SUSANNAH INGERSOLL watches guests near the opened cupboard door, which displays assorted "China" wares owned by the Upton family. The matching paneled door, as conceived by John Turner Jr. and the housewright, is a non-working deception to give the impressive room a formal, balanced appearance. Resting on the hearth is a cast-iron fire back dated 1662, discovered in the kitchen fireplace during the restoration of the house; it was made at the Saugus Ironworks, one of America's earliest industries.

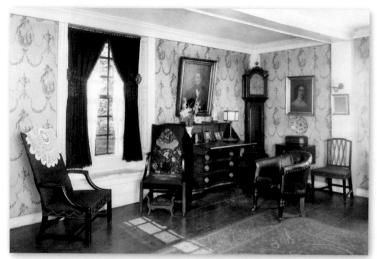

"Hepzibah attempted to enliven matters by a fire in the parlor. But the storm-demon kept watch above, and, whenever a flame was kindled, drove the smoke back again, choking the chimney's sooty throat with its own breath."
—*The House of the Seven Gables*

Parlor (postcard, circa 1915; courtesy of the Schier collection)

A LARGE AND COLORFUL "ORIENTAL" CARPET unified the parlor, which had been "decorated" with fine pieces of Colonial- and Federal-period furniture under the direction of Caroline Emmerton, possibly with the assistance of an interior decorator. A copy of Charles Osgood's 1840 oil portrait of Hawthorne and a likeness of Susannah Ingersoll flank the circa 1800 tall case clock.

"It would have been no marvel, to [Hepzibah's] excited mind, if, behind or beside her, there had been the rustle of dead people's garments, or pale visages awaiting her on the landing place above."
—*The House of the Seven Gables*

Front hallway (photograph by Cousins, circa 1890)

A VICTORIAN WALNUT HALL TREE and the functional water heater on the landing were removed from this entrance area by the historically and aesthetically attuned Caroline O. Emmerton. Revenue from The House of the Seven Gables site still funds the important activities of the Settlement Association she founded.

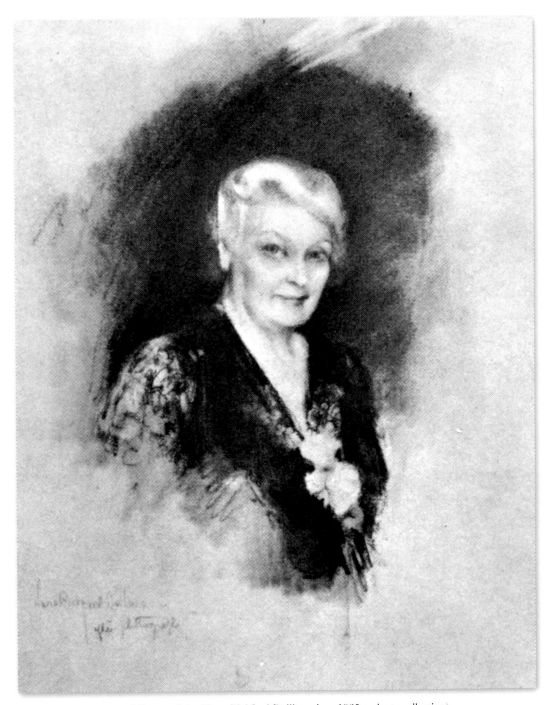

Caroline O. Emmerton (oil portrait by Nana Bickford Rollins, circa 1935; private collection)

Berkshire County Haunts

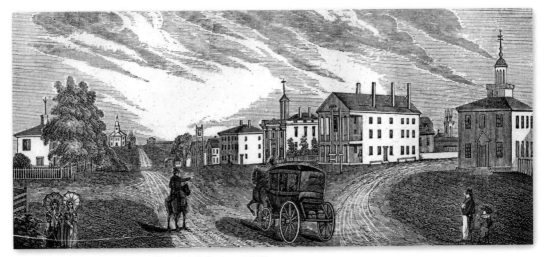

Lenox (John Warner Barber, *Historical Collections*, 1841)

"Bidding good-by forever to literary obscurity and to Salem, Hawthorne now turned his face towards the mountains."
–JH, *Nathaniel Hawthorne and His Wife*

A STAGECOACH MAKES ITS WAY DOWN the main road of Lenox (incorporated in 1767) in this charming view of the shire town in Berkshire County. The Hawthorne family moved to Lenox on May 23, 1850, to leave the chill east wind and the chilliness of Salem's social atmosphere after the publication of *The Scarlet Letter*. They discovered that many literary, artistic and musical luminaries resided in the Berkshires, such as Herman Melville, Fanny Kemble and Catherine Sigourney. While there, Hawthorne wrote several books, including *The House of the Seven Gables* and *A Wonder-Book for Girls and Boys*; his time in Lenox turned out to be the most productive period of his career. Nathaniel and Sophia greatly admired the wonderful vistas of the Berkshires—its mountains, valleys and lakes. Nathaniel, however, did not want to endure a second winter in their little red house, so they left the Berkshires on November 21, 1851.

Congregational church, 55 Main Street, Lenox (postcard, circa 1915)

"The good man [a typical early New Englander] had his reward. By a strange coincidence, the very first duty of the [church] sexton, after the bell had been hoisted into the belfry, was to toll the funeral knell of the donor."
-*A Bell's Biography*, 1837/1852

HAWTHORNE WAS NOT A CHURCHGOER; however, he may have stopped in to admire the interior space of the "Church on the Hill," as it has been known officially since 1805. This is the edifice on the horizon in the previous wood engraving by John Warner Barber.

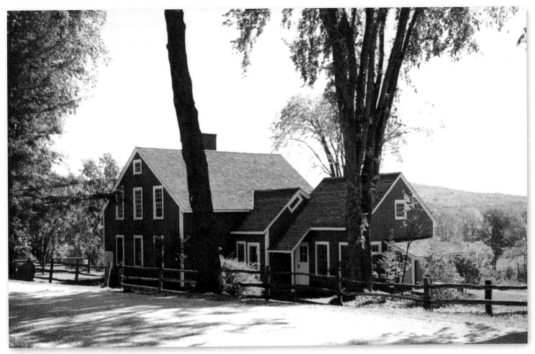

Reproduction of the "Little Red House" (postcard, circa 1950)

"I have taken a house in Lenox—I long to get into the country, for my health is not what it has been. An hour or two of labor in a garden and a daily ramble in country air would keep me all right."
—included in a letter to his lifelong friend, Horatio Bridge

THIS EARLY HEALTH WARNING was undoubtedly a concern of Sophia's. In a letter to her mother about the family's new abode, she noted, "The little reddest thing looks like the smallest of ten-foot houses." In her description of the interior she wrote, "At a mahogany stand sits your granddaughter [Una] scribbling this history. Round this pretty little hall stand four cane-bottomed chairs, my flower-table,—which survived transportation,—Julian's wee centre-table, and, at the fireplace, father's beautiful blind-fireboard. On the tiny mantelpiece reposes the porcelain lion and lamb, and a vase filled with lovely flowers." As at The Old Manse, Nathaniel inscribed his signature on a pane of glass with his wife's wedding ring: "Nathaniel Hawthorne, February 9, 1851." The Hawthornes' second daughter, Rose, was born in Lenox a few months later, on the twentieth of May. Owned by the Tappan family when the Hawthornes rented it, "La Rouge Maison" became a tourist attraction until it was destroyed by fire in 1890; the reproduction remains a Lenox attraction.

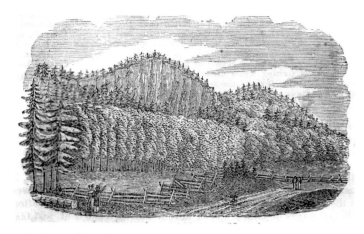

"The foliage having its autumn hues, Monument Mountain looks like a headless sphinx, wrapped in a rich Persian shawl."
—*Passages from the American Note-Books*, 1835–1853

Southeastern View of Monument Mountain (Barber, *Historical Collection*, 1841)

MONUMENT MOUNTAIN may have provided inspiration for Hawthorne's two children's books, *A Wonder-Book for Girls and Boys* (1852) and *Tanglewood Tales for Girls and Boys* (1853). Situated in Great Barrington, next to the east bank of the Housatonic River, the impressive mountain is connected with Native American lore. During an electric storm, Hawthorne and Melville sought shelter in a narrow cave there. One of Hawthorne's most widely read novels, *The House of the Seven Gables*, was penned in Lenox between September 1850 and January/February 1851; he was usually able to complete a short story or tale in about a month.

"Mr. Melville was very agreeable and entertaining…a man with a true, warm heart, and a soul and an intellect—with life to his fingertips."
—Sophia, in a letter to her mother written while living in Lenox

NATHANIEL HAWTHORNE was fifteen years Melville's senior and the two most famous American authors of the mid-nineteenth century had become friends even though Herman's scattered, rambling thoughts written in letters to Nathaniel must have been irksome. In 1851, he dedicated his famous story of *Moby-Dick or, The Whale* to Hawthorne, "In token of my admiration for his genius." Melville's summer home in Pittsfield was called Arrowhead, inspired by the former association of Native Americans.

Herman Melville (1819–1891)

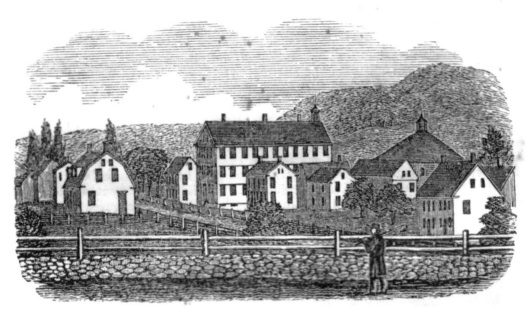

Shaker Village in Hancock (Barber, *Historical Collections*, 1841)

"An elder...from a village in Kentucky...had partaken of the homely abundance of their tables, had quaffed the far-famed Shaker cider, and had joined in the sacred dance, every step of which is believed to alienate the enthusiast from earth, and bear him onward to heavenly purity and bliss."
—*The Shaker Bridal*, 1838/1842

BARBER NOTED THAT THE SHAKERS "sprung up in this town [Hancock] about 1780," after some persons began to visit their "sainted," British-born founder, "Mother Ann" [Lee], and prominent sect leaders at Watervliet near Albany, New York. The large three-story building depicted above was made of brick; however, the most unusual structure in the church family "settlement" is the 1826 circular stone barn, far right, which housed a "span" of horses and fifty-two "horned cattle."

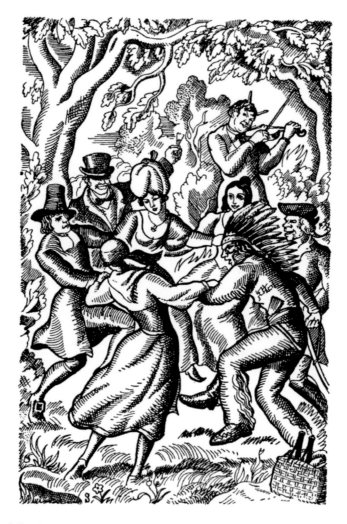

In Time and Tune (pen-and-ink drawing by an unidentified artist in *The Blithedale Romance*, 1931)

"Accompanied by these denizens of the wild wood, we went onward, and came to a company of fantastic figures, arranged in a ring for a dance or a game. There was a Swiss girl, an Indian squaw, a negro of the Jim Crow order, one or two foresters, and several people in Christian attire, besides children of all ages."
–The Blithedale Romance, 1852

THE HAWTHORNE FAMILY moved from Lenox to the temporarily vacant home of Horace and Mary Mann (Sophia's sister) in West Newton, not far from West Roxbury, where Brook Farm was located. While there, during the winter of 1851, Hawthorne wrote *The Blithedale Romance*. Old Berkshire legends inspired Nathaniel to write this novel, his first one about contemporary life, which he initially thought he might call "Hollingsworth" after one of the main characters.

The Wayside and Wanderings

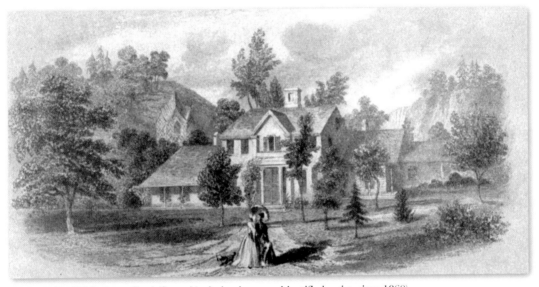

The Wayside, 455 Lexington Road, Concord (painting by an unidentified artist, circa 1860)

> *"It is really astonishing what magical changes have been wrought inside the horrible old house by painters, paperers, and carpenters, and a little upholstery…The woodwork downstairs is all painted [grained] in oak, and it has an admirable effect, and is quite in keeping with the antiquity of the dwelling."*
> —letter from Sophia to her mother, June 6, 1852

SITUATED ABOUT TWO MILES from The Old Manse on the ancient Boston Highway, The Wayside became the Hawthorne family's first real home. On March 8, 1852, for $1,500, the paterfamilias purchased from Bronson Alcott the house that he called Hillside, and by June of that year, the new owners were residing in the home they renamed The Wayside. During that summer Hawthorne enjoyed "delectable hours" on the property "stretched out at my lazy length, with a book in my hand, or an unwritten book in my thoughts." Bronson Alcott's whimsical summer house of rough stems and branches can be seen behind the dwelling in this idyllic view.

Houses of Parliament, London (postcard, circa 1900; courtesy of Wendy M. Horne)

"[London was] *a city for whose dusky immensity and multitudinous interest* [Hawthorne] *professed the highest relish.*"
–Henry James Jr.

NATHANIEL HAWTHORNE died in America in 1864, the year following the publication of his delightful, personal British travelogue *Our Old Home*. He had always wanted to visit the country from which his ancestors had emigrated and where the authors he admired most had lived and died. He also maintained that his novels and short stories would have benefited more from the layers of Old World history in England than that in New England. The opportunity to provide a nest egg for his family at last, to spend time in England and to visit other European countries such as Italy came from his longtime friend, then-President Franklin Pierce. Hawthorne was appointed United States consul at Liverpool, and he served his country admirably in that capacity from August 1, 1853, until October 12, 1857. Nathaniel, Sophia and their three children adapted to the challenges presented during his work in Liverpool and their European sojourn until they returned to the United States in the summer of 1860. In a letter to his publisher friend William D. Ticknor (who was keeping track of the consul's finances), Hawthorne wrote, "I never felt better in my life. England is certainly the country to eat in, and to drink in."

Bust of Nathaniel Hawthorne (photograph by Cousins, circa 1890; courtesy and permission of the Concord Free Public Library, Concord, Massachusetts)

"His limbs were beautifully formed, and the moulding of his neck and throat was as fine
as anything in antique sculpture…His head was large and grandly developed; his eyebrows
were dark and heavy, with a superb arch and space beneath. His nose was straight, but the
contour of his chin was Roman."
–JH, *Nathaniel Hawthorne and His Wife*

SALEM-BORN SCULPTOR LOUISA LANDER (1826–1923) signed and dated this white marble bust of fifty-four-year-old Hawthorne "L.L. ROMAE. 1858." The shape of the author's chin was unfortunately changed from the clay model when someone who knew him criticized that feature. Not regarded favorably by his aesthetic friends in Italy, the bust accompanied the Hawthorne family when they returned to America. Around 1873, it was presented to the Concord Free Public Library. Shortly after his tour of duty as consul ended, Hawthorne and his family vacationed in Rome for two cold winters, separated by one delightful summer in Florence, where he was inspired to write *The Marble Faun*.

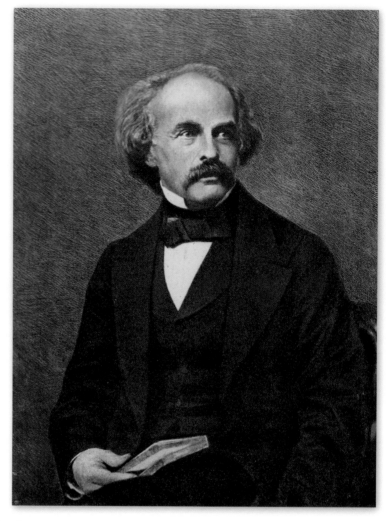

Hawthorne at the age of fifty-six (engraving after the photograph by J.J.E. Mayall, 1860)

"The only sensible ends of literature are, first, the pleasureable toil of writing; second, the gratification of one's family and friends; and lastly, the solid cash."
–Nathaniel Hawthorne

THIS PHOTOGRAPH WAS TAKEN on May 19, 1860, in London, slightly more than a month before the Hawthorne family returned to America and their home in Concord. While in Italy in April of 1859, Hawthorne began to grow a moustache—a permanent distinctive feature to his still attractive appearance. In revealing some of his inner thoughts, he noted, "A cloudy veil stretches over the abyss of my nature. I have, however, no love of secrecy and darkness. I am glad to think that God sees through my heart, and if any angel has power to penetrate into it, he is welcome to know everything that is there."

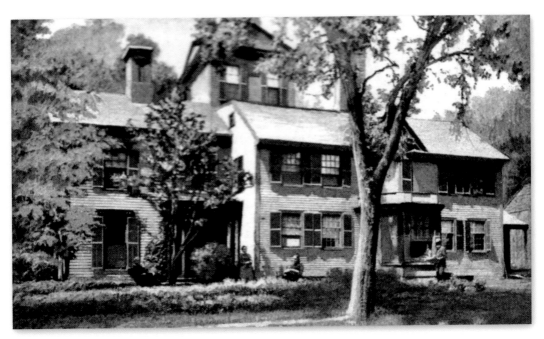

The Wayside (photograph, possibly of Lothrop family members, in *Literary Shrines*, 1895)

"A good many alterations have been made…about the place…that engaged Hawthorne's attention in this life."
–JH, *Nathaniel Hawthorne and His Wife*

AFTER THEIR RETURN FROM ENGLAND in late June of 1860, the Hawthorne family lived at The Wayside during and slightly beyond the eventful years of the Civil War. This stressful period of time caused Nathaniel's low spirits to accompany his failing health. In October of 1868, four years after "Mr. Hawthorne's" death, Sophia took her three children to Dresden, Germany, where she enrolled Julian in an engineering course, and then to London, where she and her daughters lived with the Francis Bennoch family. In 1870, Sophia sold The Wayside, and a year later she died of typhoid pneumonia on February 26, 1871. The home then passed through two different owners before it was acquired in 1879 by family members Rose Hawthorne and her husband George Parsons Lathrop, who resided there until 1881. Two years later, in 1883, the dwelling and its acreage were purchased by Boston publisher Daniel Lothrop. Writing under the pseudonym of Margaret Sidney, his wife, Harriett M. Lothrop (1844–1924), wrote the children's book *The Five Little Peppers and How They Grew*, and other popular books in the series. Mrs. Lothrop had "an appreciable reverence for Hawthorne…which led her to preserve his home and its belongings essentially unchanged." Harriett's daughter, Margaret M. Lothrop (1884–1970), a sociologist and preservationist, inherited The Wayside in 1924. She cared for and loved the "Home of Authors," and resided there until it became a National Historic Landmark in 1963, and then the property of the Minute Man National Historical Park on June 15, 1965.

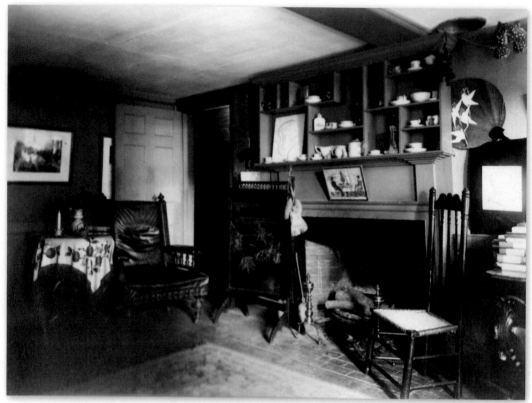

Sitting room, The Wayside (photograph by Cousins, circa 1904)

> *"The morning hearth, too, is newly swept, and the brazen andirons well brightened, so that the cheerful fire may see its face in them."*
> –*Fire-Worship*, 1843/1846

THIS "ANTIQUE RECEPTION-ROOM," with two windows fronting the street, was the former dining room of the Alcott and Hawthorne families. Cubbyholes above the mantelpiece have been "artistically fitted and embellished with rare pottery [predominately Chinese export porcelain tea wares]." In front of the mantel is a fireplace screen with a painted and written insert by Rose Hawthorne that she presented to Harriett Lothrop. Writing to her mother in early June of 1852, Sophia stated, "The study [now referred to as the piazza; see page 108] is the pet room, the temple of the Muses and the Delphic Shrine. The beautiful carpet lays the foundation of its charms, and the [grained] oak woodwork harmonizes with the tint in which Endymion [Hawthorne] is painted...On another side of the Study are the two Lake Comos [and] that agreeable picture of [Martin] Luther and his family around the Christmas-tree, which Mr. George Bradford gave to Mr. Hawthorne." (RHL)

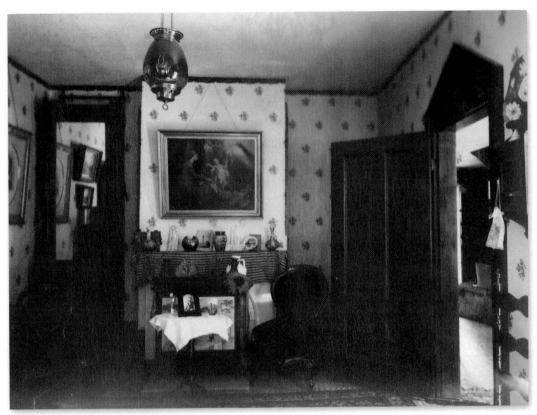

Parlor, The Wayside (photograph by Cousins, circa 1904)

"So we descended the hill to my small, old cottage, and shut ourselves up in the south-eastern room, where the sunshine comes in, warmly and brightly, through the better half of a winter's day."
–Twice-Told Tales

THE PARLOR IS LOCATED on the first floor of the distinctive tower addition that Hawthorne had built onto The Wayside. The large chromolithograph of the oil painting *Madonna and Family* was produced by Erich Orrens around the mid-nineteenth century. A taupe-colored plaster group by the Salem sculptor John Rogers (1829–1904) is in front of the fabric-covered mantelpiece.

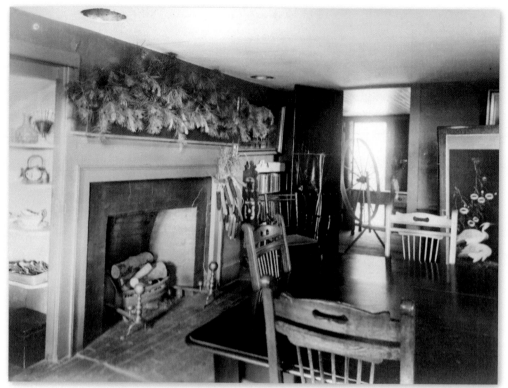

Dining room, The Wayside (photograph by Cousins, circa 1904)

"The dining-room is quite elegant, with a handsome [wall] paper having a silvery sheen, and the brown and green Brussels carpet."
—Sophia, in a letter to her mother, June 6, 1852

SOPHIA ALSO NOTED, "At the dinner-table she [Una] converses about Leonardo da Vinci's Madonna of the Bas Relief, which hangs over the fireplace." Maternally proud Sophia wrote that her daughter "observes all the busts and pictures, and Papa says he is going to publish her observations on art in one volume octavo next spring…and she talks a great deal about Michael Angelo's frescos of the Sibyls and Prophets, which are upon the walls of the dining-room." Interestingly, "Papa" was not at all religious, so the pictures may have been purchased or acquired by Sophia for their home. During the Alcott and Hawthorne family years at the house, respectively, this space was the sitting room. After 1860 it became Julian's bedroom because he wanted to be on the first floor. Finally, when the Lothrop family acquired the property, it became the dining room abundantly decorated with leafy boughs, as shown.

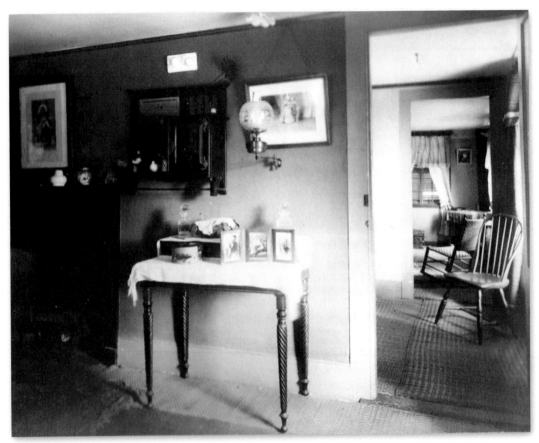

West chamber, The Wayside (photograph by Cousins, circa 1904)

THIS IS A PARTIAL VIEW of the west chamber, which was the master bedroom of the Alcott and Hawthorne families; beyond is the east chamber, which was probably used as a guest room. The mahogany Sheraton dressing table appears to be of Salem origin and is thought to be a Hawthorne family piece. Second-floor rooms also featured woven straw carpeting at this time, usually more in evidence after the wool carpets were removed for the summer months. Beginning in 1906, Harriett Lothrop had electricity installed throughout the house, two years after the centennial birthday celebration of the dwelling's most famous author on July 4.

Piazza, The Wayside (photograph by Cousins, circa 1904)

PLASTER BUSTS OF TWO ILLUSTRIOUS American statesmen, Benjamin Franklin and Daniel Webster, were on display in this room before they were transferred to Hawthorne's tower study. The tragic death by drowning of Margaret Fuller, her husband, the Marquis Giovanni Ossoli, and their son on the merchant vessel *Elizabeth* that was bringing them to America in 1850 was compounded by the Hawthorne family's unexpected loss of Nathaniel's sister, Louisa, to a similar fate on the steamer *Henry Clay* on the Hudson River on July 27, 1852. After the exhausting and hurried completion of the *Life of Franklin Pierce* that same year, the emotionally distraught author took a three-week vacation. Hawthorne enjoyed the Isles of Shoals off Portsmouth, New Hampshire, after he attended the fiftieth anniversary of the founding of Bowdoin College. He intentionally arrived too late to give an address and then be honored for the literary success of his first two major novels.

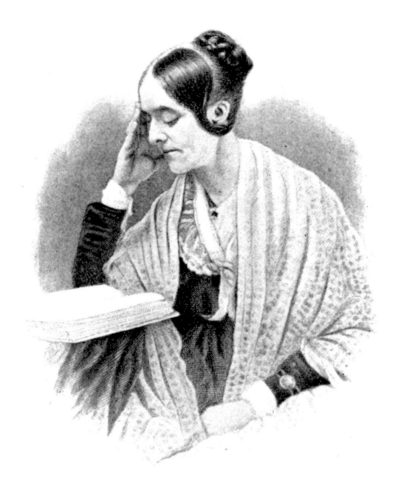

Margaret Fuller (engraving in *The Bookman*, 1898)

"This Sybil—of the curled locks, high forehead, half-closed eyes, over-laced corsage and beautiful arms—with prehensile grip of taper fingers—launched away into her smooth-flowing, rapturous but immethodical talks."
–Donald G. Mitchell, *American Land and Letters*, 1899

"THE CAVILING, ELOQUENT, self-contained conversationalist" was smart and forceful in her interactions with fellow Transcendentalists. Born in 1810, Fuller edited their newspaper, *The Dial*, for two years, between 1840 and 1842. In 1846, Miss Fuller traveled to Italy to become a journalist for the *New York Tribune*, and while there she met and married Ossoli, who was eleven years her junior.

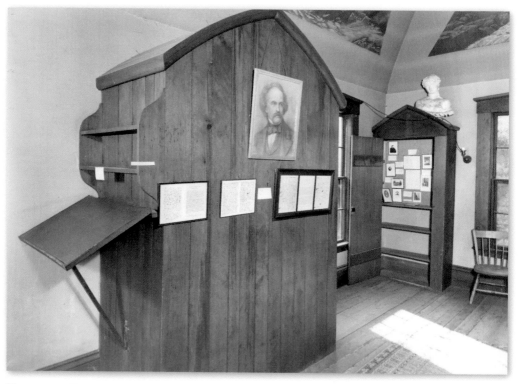

Tower room, The Wayside (photograph, circa 1950; courtesy of the Minute Man National Historical Park)

"When his health began to show signs of giving way, in 1861, it was suggested by a relative…that my father only needed a high desk at which to stand when writing, to be restored to all his pristine vigor. With his usual tolerance of possible wisdom he permitted such a desk to be arranged in the tower-study…but with his inexorable contempt for mistakes of judgment he never, after a brief trial, used it for writing."
–JH, *Nathaniel Hawthorne and His Wife*

VERY NARROW AND STEEP STAIRS lead to the one-room study in the "sky-parlor," which became Hawthorne's personal literary haunt. The twenty-foot-square room has four gables, a vaulted ceiling and featured pale gold wallpaper similar to what he and Sophia had selected for his study at The Old Manse. The ratchet-type desk is shown here, but not the simple walnut desk on which Hawthorne kept a souvenir from Rome—the "charming bronze inkstand, over whose cover wrestled the infant Hercules in the act of strangling a goose." Hawthorne's novel, *Our Old Home*, which includes sketches of English life previously included in the *Atlantic Monthly*, was published in 1863, but he was unable to complete other works such as *Septimius Felton* and *Doctor Grimshawe's Secret*.

Larch walk (photograph by Cousins, circa 1904)

"In a forest, solitude would be life; in a city, it is death."
–The New Adam and Eve, 1843/1846

HAWTHORNE ORDERED NORWAY PINE and larch saplings while he lived in England. The young larch trees were thriving on the pathway between The Wayside and Orchard House, the Alcott family home, when Frank Cousins took this photograph. In solitary thought, Hawthorne walked for hours under the larches on the path he referred to as "the only remembrance of me that will remain." (*The Bookman,* 1898)

Hawthorne and his Publishers Ticknor and Fields (photograph, circa 1861/62 in *The Bookman*, 1898)

"A portrait of those tall hats."
–remark made by Hawthorne's British friend Francis Bennoch to George
Parsons Lathrop in the *Century Magazine*, April 1887

THE FAMOUS AMERICAN AUTHOR is flanked by his associates in the original daguerreotype
taken by James Wallace Black of Boston, whose studio was located then at 173 Washington
Street. Now regarded as the "open manuscript pose," Hawthorne is looking to his right
at James T. Fields, the junior partner in the publishing firm. In the other almost identical
daguerreotype with the closed manuscript, he is shown smiling at Fields. A tall, silk
stovepipe hat and a knee-length "black dress-coat and pantaloons" were a gentleman's
standard exterior attire around the mid-century.

The Capitol Building in Washington, D.C. (photograph, July 11, 1863)

A DERRICK IS SITUATED ON THE DOME of the unfinished Capitol in this view taken from the east front of the building. Residents of the city numbered fewer than seventy thousand at that time, many of whom were connected in some way with the government. On Hawthorne and Ticknor's first visit to the Capitol during the new administration of Franklin Pierce in April of 1853, the author hoped he might receive a political appointment from his friend, which he did. And on their second visit in March of 1862 (almost a year after the Civil War began), they met another president, Abraham Lincoln. Emanuel Leutze (1816–1868), who was preparing to paint his fresco *Westward the Course of Empire Takes Its Way* in the Capitol, convinced Hawthorne to sit for an oil portrait, which the author described as "the best ever painted of the same unworthy subject." (Caroline Ticknor, *Hawthorne and His Publisher*, 1913)

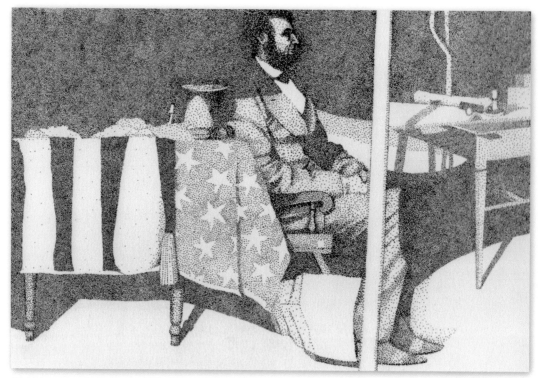

Abraham Lincoln in General McClellan's tent at Antietam, October 3, 1862 (detail of the pen-and-ink pointillist drawing by this author, 1963)

"In lounged a tall, loose-jointed figure, of an exaggerated Yankee port and demeanor, whom (as being about the homeliest man I ever saw, yet by no means repulsive or disagreeable) it was impossible not to recognize as Uncle Abe."
—Ticknor, *Hawthorne and His Publisher*

"**CHIEFLY ABOUT WAR MATTERS,**" an essay by Hawthorne on the beginning of the Civil War, was published in the July issue of the *Atlantic Monthly*, after his return from the District of Columbia. Sections of the essay, including the description of "Uncle Abe," were deleted by publisher Fields because he thought they would "outrage the feelings of many [Northern] Atlantic readers." The dedication of *Our Old Home* in 1863 to former President Pierce aroused criticism due to Pierce's alleged pro-Southern sympathies. Hawthorne was glad that teenage Julian was too young to join in the war effort.

Nathaniel Hawthorne (photograph, by
Alexander Gardner for Mathew Brady, 1862;
in *American Lands and Letters*, 1899)

*"He looks gray and grand, with something very pathetic about
him."*
—Henry Wadsworth Longfellow

FELLOW AUTHOR LONGFELLOW made this remark
more than a year before Hawthorne's death. Sophia
wrote in a letter to Una in 1863 that he had lost
his zest for life four to five years ago. "I am amazed
that such a fortress as his digestion should give way,"
she noted. "But his brain has been battering it for a
long time,—his brain and his heart. The splendor
and pride of strength in him have succumbed…
he must be handled like the airiest Venetian glass."
Interestingly, while serving as consul in Liverpool,
Hawthorne was "brain-stricken" one day.

On the Beverly Coast, Massachusetts (engraving, by D. Appleton & Co.,
1874, after the painting by John F. Kensett; courtesy of Ellen Neily)

*"If the weather is favorable, [Julian
and I] shall have little to do with the
inside of the house, but shall haunt
the woods and the seashore."*
—JH, *Nathaniel Hawthorne and
His Wife*

HOPING THAT A SHORT SEASHORE HOLIDAY would improve his father's "depressed
energies and spirits," Julian took him to the West Beach area in Beverly Farms. They were in
this "out-of-the-way place" in late July of 1861, relaxing on the beach, swimming and fishing.
Writing to his daughter Una, Hawthorne joked about the "abundant accommodations" at
West Beach. At the same time, he was also concerned for her ongoing health problems
related to the "Roman fever" (malaria) she had contracted during their vacation in Italy.

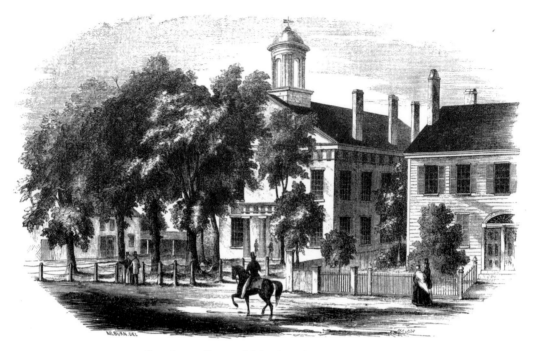

Courthouse, Bangor, Maine (wood engraving, 1853)

"His [and Julian's] journey [to Maine] was marked by rain, fog, and various discomforts which made the trip hardly one of unmitigated pleasure for Hawthorne, but, in the end, it proved a beneficial change from the routine of the Concord existence."
—Ticknor, *Hawthorne and His Publisher*

FOR MORE THAN TWO WEEKS during the latter part of August 1862, the father-and-son duo rented a small farmhouse by the beach in West Gouldsboro, Maine, on the mainland opposite Mount Desert. Weather permitting, they went rowing every day, explored adjacent islands, fished for flounder and swam; Nathaniel enjoyed a daily cigar and the rest provided by the vacation. Before they returned home to The Wayside in early September, they had traveled by stagecoach to other picturesque Maine destinations, including Bangor, Bath and Hallowell. Julian later wrote that it was the last trip he enjoyed with his adored father. Bangor became a city in 1834, and five years later it was noted for being "the greatest depot for lumber on the continent of America."

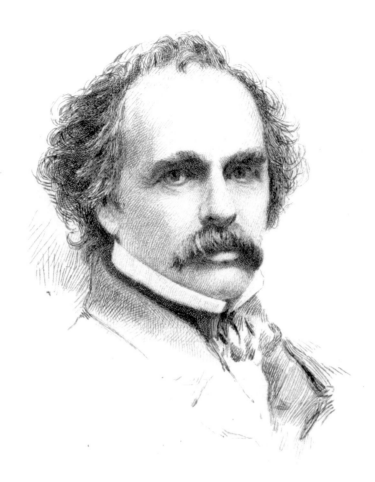

Hawthorne at the Age of Fifty-eight (etching by Schoff, 1884)

"He has the look all the time, to one who doesn't know him, of a rogue who finds himself suddenly in a company of detectives."
—quotation by Hawthorne biographer Henry James

JULIAN WROTE THAT HIS FATHER "never seemed old to us, however, even to the last." Hawthorne's creativity and appearance coincided with his failing health, shown here two years before his demise. "The war continues to interrupt my literary career," he wrote by the middle of May 1862, "and I am afraid it will be long before Romances are in request again, even if I could write one." (Ticknor, *Hawthorne and His Publisher*)

Independence Hall, Philadelphia, Pennsylvania (postcard, circa 1900)

> *"As the architecture of a country always follows the earliest structures, American architecture should be a refinement of the log-house. The Egyptian is so of the cavern and mound; the Chinese, of the tent; the Gothic, of overarching trees; the Greek, of a cabin."*
> —*Passages from the American Note-Books*

HAWTHORNE'S GOOD FRIEND and cheery publisher, William D. Ticknor, planned another trip to Washington, D.C., for the ailing author's health. When they began the vacation in March of 1864, inclement weather kept them hotel-bound for a week in New York City. Then they ventured on to Philadelphia, the historic center of which looked much as it did in this image. It was there that Ticknor caught a severe cold and succumbed to congestion of the lungs on the tenth of April, leaving a physically weakened and bereft Hawthorne to make arrangements for his friend's body to be returned to Boston. This totally unexpected event undoubtedly hastened the author's death one month later.

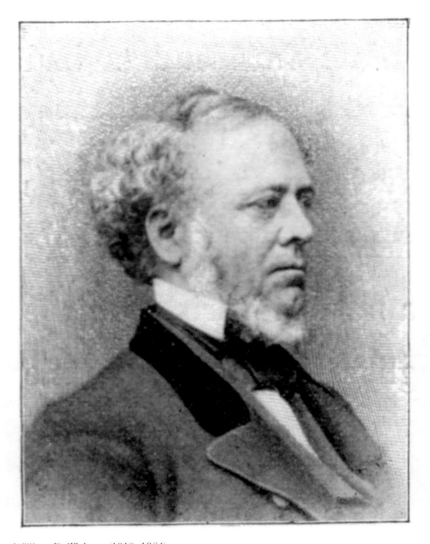

William D. Ticknor (1810–1864)

"Never was a man endowed with a warmer affection for his own, or with the capability of a more truly unselfish devotion to his friends…but when a matter of financial fairness or business integrity was at stake, all men stood on a plane of absolute equality."
—Ticknor, *Hawthorne and His Publisher*

BORN IN LEBANON, NEW HAMPSHIRE, seventeen-year-old Ticknor set out for Boston to embark on his career, which included experience in banking before publishing became the main focus of his life. The early eighteenth-century brick Old Corner Book Store on the corner of Washington and School Streets was the gathering place in Boston for aspiring authors, including Hawthorne, who frequented the business and began his brotherly friendship with senior partner Ticknor.

Pemigewassett House, Plymouth, New Hampshire (photograph, late nineteenth century; courtesy of the Peabody Essex Museum)

"Death is too much of an event to be wished for."
–JH, *Nathaniel Hawthorne and His Wife*

BOTH NATHANIEL AND SOPHIA realized that it would be the final parting of their love-filled marriage when he left The Wayside to meet "Frank" Pierce in Boston for their trip to the White Mountains. Situated in central New Hampshire near Squam Lake, the Pemigewassett House was a large, white clapboard hotel adjacent to the railroad station; it was a popular location for those wanting to explore the natural majesty of the area. Hawthorne had attended the funeral of Mrs. Pierce in December of 1863 in New Hampshire, and now both lifelong friends would be together there again for the last time. Franklin requested adjoining rooms so that he could watch over Nathaniel's quickly deteriorating condition; after he checked on him a second time around three o'clock in the early morning, he noticed that his old college chum was no longer breathing. The cause of his death on May 19, 1864, has never been determined, as no physician was there at that time and an autopsy was not performed. Hawthorne may have had stomach cancer, which then spread to his brain.

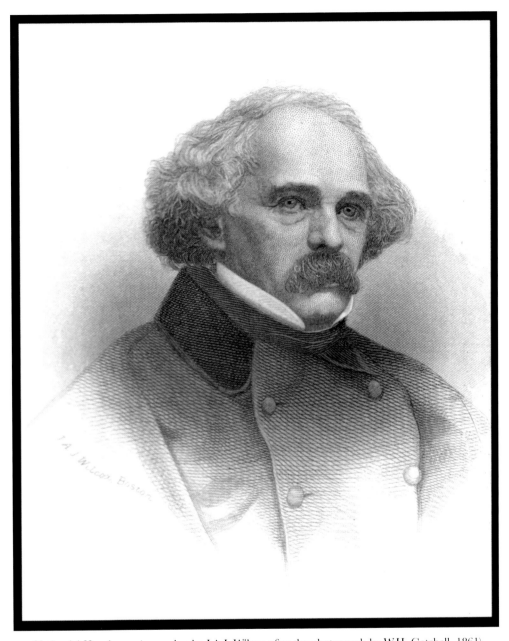

Nathaniel Hawthorne (engraving by J.A.J. Wilcox after the photograph by W.H. Getchell, 1861)

"It is enough that the stony soil of New England could bear such fruits of the imagination as he has garnered for our wonder and delight."
—M.A. DeWolfe Howe, *The Bookman,* 1898

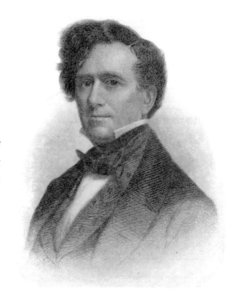

"To Franklin Pierce, as a slight memorial of a college friendship, prolonged through manhood, and retaining all its vitality in our autumnal years, this volume is inscribed by Nathaniel Hawthorne."
—Our Old Home

Franklin Pierce (engraving in *American Lands and Letters*, 1899)

"On Monday, the twenty-third of May, [Hawthorne's] *body was given back to earth in the place where he had long lived, and which he had helped to make widely known,—the ancient town of Concord…In a patch of sunlight, flecked by the shade of tall, murmuring pines, at the summit of a gently swelling mound where the wild-flowers had climbed to find the light and the stirring of fresh breezes, the tired poet was laid beneath the green turf."*
—Dr. Oliver Wendell Holmes

Hawthorne's grave at Sleepy Hollow Cemetery, Concord (photograph by Cousins, circa 1904)

A FEW DAYS LATER, Sophia wrote, "There can be no death nor loss for me for evermore… God gave me the rose of time; the blossom of the ages to call my own for twenty-five years of human life." On June 26, 2006, the remains of Sophia and Una, both of whom had been buried at fashionable Kensal Green in West London in 1871 and 1877, respectively, were reinterred at Sleepy Hollow Cemetery in a special ceremony.

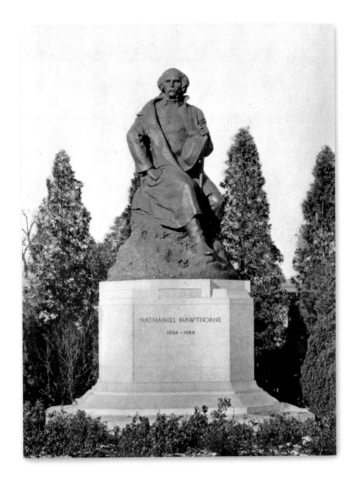

Statue of Nathaniel Hawthorne, Hawthorne Boulevard, Salem (photograph, 1925; courtesy of the Schier collection)

"It has been, indeed, a pious labor for us to renew the renown of this departed son and to give to the city of his birth so appropriate a memorial to his great worth."
–address by Judge Alden Perley White

ON DECEMBER 23, 1925, following a preliminary ceremony at the Second Church on Washington Square (which included an organ prelude, additional music and the address by Judge White), the dignitaries and interested onlookers proceeded to the prominent location where the statue was unveiled by Rosamond Mikkelsen, the great-granddaughter of Nathaniel Hawthorne. Bela Lyon Pratt (1867–1917) based his sculpture on an 1861 photograph of the author and it was cast in bronze by the Gorham Company of Providence, Rhode Island. Coincidentally, in *Edward Randolph's Portrait*, Hawthorne wrote, "As we touched our glasses together, my legendary friend made himself known to me as Mr. Bela Tiffany; and I rejoiced at the oddity of the name, because it gave his image and character a sort of individuality in my conception."

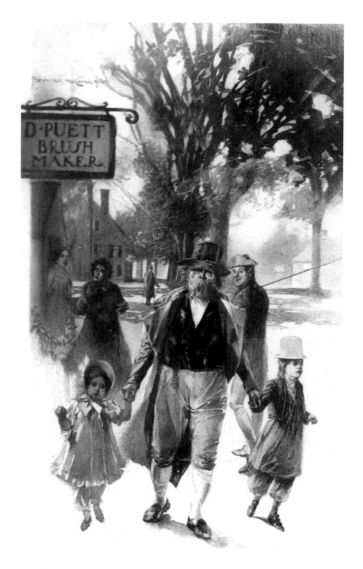

Doctor Grimshawe's Secret (illustration by Frederick McCormick, in *The Complete Works of Nathaniel Hawthorne*, Fireside Edition, 1882)

"There he goes, the old spider-witch!"
—Doctor Grimshawe's Secret

IN ADDITION TO *Doctor Grimshawe's Secret*, several other unfinished stories and tales by Hawthorne were published posthumously: *Pansie: A Fragment* (1864); *Passages from the American Note-Books* (1868); *Passages from the English Note-Books* (1870); *Passages from the French and Italian Note-Books* (1871); *Septimius Felton; or, the Elixir of Life* (1872); *The Dolliver Romance and Other Pieces* (1876); *Fanshawe and Other Pieces* (1876); and *Sketches and Studies* (1883).

Bibliography

Barber, John Warner. *Historical Collections of Every Town in Massachusetts.* Worcester, MA: Dorr, Howland & Company, 1840.

The Bookman: An Illustrated Literary Journal, Vol. VI. New York: Dodd, Mead and Company, 1898.

The Complete Works of Nathaniel Hawthorne: Fireside Edition, Vols. I, III, XII. Boston and New York: Houghton, Mifflin & Company, 1883.

Crawford, Mary Caroline. *Romantic Days in Old Boston.* Boston: Little, Brown, and Company, 1912.

Dedication of the Nathaniel Hawthorne Memorial 1804–1864 at Salem, Massachusetts. Salem: Newcomb & Gauss, 1926.

Emmerton, Caroline O. *The Chronicles of Three Old Houses.* Salem, MA: The House of the Seven Gables Association, 1935.

Gollin, Rita K. *Portraits of Nathaniel Hawthorne: An Iconography.* DeKalb: Northern Illinois University Press, 1983.

Hawthorne, Julian. *Hawthorne and His Circle.* New York: Archon Books, 1968.

———. *Nathaniel Hawthorne and His Wife, Vols. I & II.* Boston and New York: Houghton Mifflin and Company, 1897.

———, ed. *The Works of Nathaniel Hawthorne: Twice-Told Tales, The Blithedale Romance.* New York: Peter Fenelon Collier & Son, 1900.

Hawthorne, Nathaniel. *The Great Stone Face and Other Tales of the White Mountains.* Boston and New York: Houghton Mifflin Company, 1882.

————. *The House of the Seven Gables*. New York: The Heritage Press, 1935.

————. *In Colonial Days*. Boston: L.C. Page & Company, 1906.

————. *The Marble Faun*. Boston and New York: Houghton, Mifflin and Company, 1883.

————. *Passages from the American Note-Books*, 1835–1853. Boston and New York: Houghton, Mifflin and Company, 1868.

————. *The Scarlet Letter*. London & Glasgow: Collins' Clear-Type Press, n.d.

James, Henry. *Hawthorne*. New York: Harper & Brothers, 1879.

Lathrop, George Parsons. *Tales, Sketches, and Other Papers by Nathaniel Hawthorne With a Biographical Sketch*. Boston and New York: Houghton, Mifflin and Company, 1887.

Lathrop, Rose Hawthorne. *Memories of Hawthorne*. Boston and New York: Houghton, Mifflin and Company, 1897.

Mitchell, Donald G. *American Lands and Letters*. New York: Charles Scribner's Sons, 1899.

Morris, Lloyd. *The Rebellious Puritan: Portrait of Mr. Hawthorne*. New York: Harcourt, Brace and Company, 1927.

Murphy, Emily A. *Nathaniel Hawthorne's Salem: A Walking Tour of Literary Salem in the Early Nineteenth Century*. Fort Washington, PA: Eastern National, 2007.

Mussey, Barrows. *Old New England*. New York: A.A. Wyn, Inc., 1946.

Northend, Mary Harrod. *Historic Doorways of Old Salem*. Boston and New York: Houghton Mifflin Company, 1926.

Phillips, James Duncan. *Salem and the Indies*. Boston: Houghton Mifflin Company, 1947.

The Photographic History of the Civil War in Ten Volumes, Vol. III. New York: The Review of Reviews Company, 1911.

Ticknor, Caroline. *Hawthorne and His Publisher*. Boston and New York: Houghton Mifflin Company, 1913.

Tolles, Bryant F., Jr. *Architecture in Salem: An Illustrated Guide*. Salem: The Essex Institute, 1983.
Wolfe, Theodore F. *Literary Shrines*. Philadelphia: J.B. Lippincott Company, 1895.

Wright, John Hardy. *Sorcery in Salem*. Charleston, SC: Arcadia Publishing, 1999.

Ladye [*sic*] *Eleanore's Mantle* (pen-and-ink drawing by Frank T. Merrill, *In Colonial Days*, by Nathaniel Hawthorne, 1906)